the land of the Incas

the land of
the Incas

photographs by Hans Silvester
text by Jacques Soustelle

with 138 illustrations and a map

Thames and Hudson

The illustrations accompanying the text are taken from the
Nueva Corónica y Buen Gobierno, a Peruvian illustrated codex
of the early seventeenth century with text by Felipe Guamán
Poma de Ayala. Now in the Kongelige Bibliotek, Copenhagen,
it was reproduced in 1936 by the Institut d'Ethnologie, Paris,
under the discretion of Professor Paul Rivet.

All the photographs were taken with Leica and Leicaflex cameras
and a selection of Leitz lenses ranging from 28 to 400 mm.

Translated from the French
La Route des Incas
by Jane Brenton

First published in Great Britain in 1977
by Thames and Hudson Ltd, London
First paperback edtion published in 1986
by Thames and Hudson Inc., 500 Fifth Avenue,
New York, New York 10110
Reprinted 1994

Previously published in the United States of America
as *The Route of the Incas*

English translation c 1977 Thames and Hudson Ltd, London

© 1976 and 1986 Hans Silvester (photographs), Jaques Soustelle (text)
and Sté Nlle des Editions du Chêne, Paris

Library of Congress Catalog Card Number 86-50334

British Library Cataloguing-in-Publication Data

A catalogue record for this book is available from the British Library

ISBN 0-500-27430-4

Printed in Switzerland and bound in France

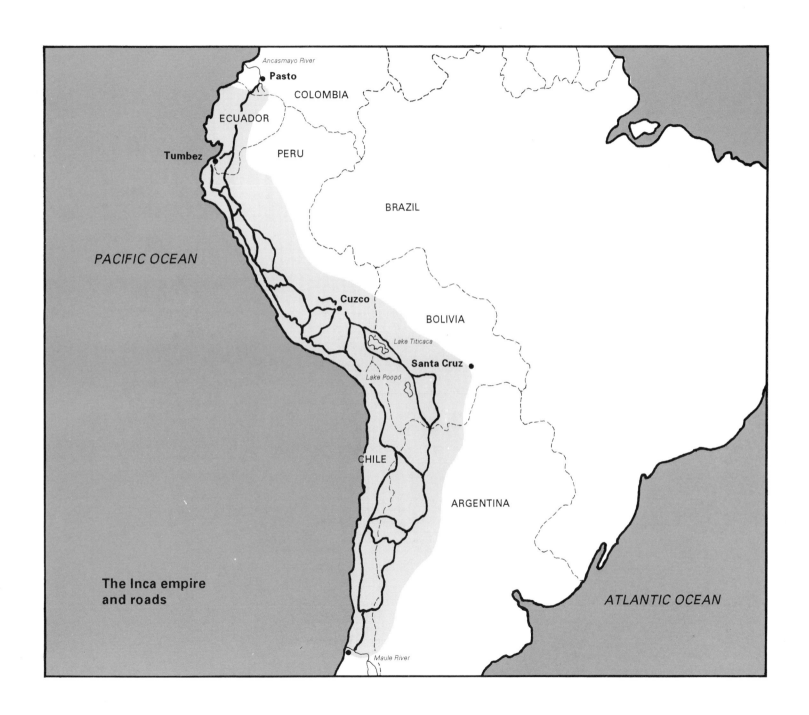

PACIFIC OCEAN

ATLANTIC OCEAN

Ancasmayo River

Pasto

COLOMBIA

ECUADOR

Tumbez

PERU

BRAZIL

Cuzco

BOLIVIA

Lake Titicaca

Santa Cruz

Lake Poopó

CHILE

ARGENTINA

**The Inca empire
and roads**

Maule River

EL DECÍMOÍNGA
TOPAÍNGA·IV
PANQVÍ

Reyno tarma·dh
ta atopillo·nos
bueno·uay llas—
chayrocha·uarochiri·con
ya·has·chus·tay·conchoco-
uaranga·uuno·to·allanca·ydhoca·ua
topa

Mama Coya, the empress

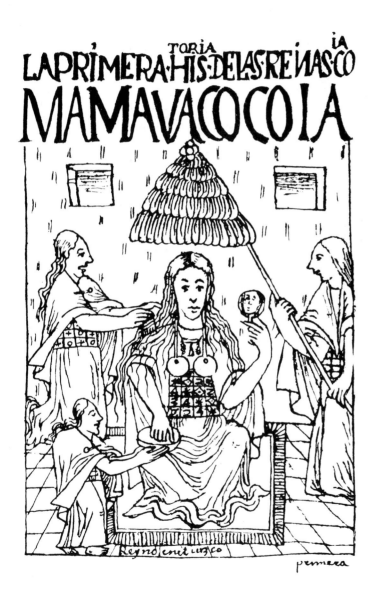

LA·PRIMERA·HIS TORIA·DE LAS RE NAS CO IA
MAMAVACOCOIA

It was Vasco Nuñez de Balboa the *conquistador* who discovered the vast Pacific lying beyond the isthmus of Panama, who was the first European to hear of the existence of Peru.

The incident took place in 1511, nineteen years after the happy accident of the discovery of America by Christopher Columbus, who mistakenly believed he had reached India. The Spanish were occupying the Bahamas, Cuba, Haiti, the Antilles and a part of Panama. The rest of the continent was a blank. They knew nothing of its two great empires, the Aztecs in the north, the Incas in the south. But one day Balboa was weighing objects of gold that he had obtained from the Indians when a young chief exclaimed: 'If you set such store by this gold that you are ready to leave your distant country and even risk your life for it, then I can tell you of a land where the people eat and drink from dishes and vessels made of gold.'

In the event Balboa was not destined to be the conqueror of the Land of Gold. He did lead an expedition to the south of the isthmus, where he acquired more precise information, and was even shown drawings of a strange animal that appeared to be a cross between a sheep and a camel and was in fact the llama. But he vanished from the scene when he was relieved of his command and thrown into prison by the jealous governor, Pedrarias, ultimately being sentenced to death and beheaded in 1519. A common adventurer named Francisco Pizarro, who had shared in Balboa's exploits for a time, then joined forces with a brave but equally uneducated soldier called Diego de Almagro and an influential priest, Father Hernando de Luque, who set about raising the money necessary to mount an expedition of discovery to the south.

The chronicler Montesinos records an agreement dated 10 March 1526, an astonishing document in which the two captains and the priest divide up in advance 'the kingdoms and provinces of Peru', the 'revenues, domains, vassals and *repartimientos* of the Indians', the 'hidden treasure, gold, silver, pearls, emeralds, diamonds and rubies'. Father de Luque was promised a third share of the spoils in return for 'twenty thousand *pesos* in gold bars'.

The name Peru – which arose from a misunderstanding on the part of the Spaniards when the Indians told them the name of a river – was already in their minds a synonym for gold, precious

stones and treasure. But the first attempts to lay hands on these riches were disappointing, and Pizarro and Almagro came near to abandoning the entire project. They did, however, get as far as Tumbes, the most northerly port of the Inca empire, and Pizarro was able to obtain a few articles of gold and silver, some fine patterned cloth and two or three llamas before setting sail for Spain in 1528. He was given an audience by Charles V in Toledo and obtained from him a form of covenant appointing him Governor and Captain-General of the conquered territories of Peru, or 'New Castille' as it was called. Almagro was named commander of the fortress at Tumbes, and Father Hernando de Luque was awarded the bishopric of the town together with the title 'Protector of the Indians' and emoluments of one thousand ducats a year. In this way the shady deal concluded in Panama between the two adventurers and the priest was given the sanction of the most powerful monarch in the world.

While their fate was being decided in Europe, the Indians of Peru were tearing themselves apart in bloody civil war, as yet unaware of the trouble that was brewing far from their continent. In Mexico it had been the hatred of the Tlaxcalans for the Aztec empire that made them throw in their lot with Cortés and facilitated his conquest, and in Peru the fratricidal combat of the two heirs to the Inca throne was to deliver the country into the hands of Francisco Pizarro in much the same way. In the south as in the north, tribal or dynastic rifts had so undermined the powerful edifices of empire that they toppled before the determined invading forces, small in numbers though these were. Pizarro set out from Panama in 1531 with three small ships, one hundred and eighty soldiers and twenty-seven horses; meanwhile in Peru the supporters of the two warring brothers were massacring each other in their tens of thousands.

The truth of the matter is that the Spanish were not called upon to confront the Inca empire as it had been in the days of the great Sun Emperors. The northern kingdom of Quito (modern Ecuador) was at war with Peru in the south. The last Inca of the direct line, Huayna Capac, had died in Quito in 1525 after a reign of forty years. As heir apparent to the throne and later as ruler he had overrun the kingdom of Quito and established the northern-most frontier of the empire. He spent the last years of his life in

Quito, far away from Cuzco and the traditional responsibilities of the Peruvian sovereign. His principal wife (who was also his sister, following the custom of the imperial family) had given him a son, Huascar, destined to follow him to the throne, while another of his wives, the daughter of the last ruler of Quito, was the mother of Prince Atahuallpa. Huayna Capac was so devoted to this son that shortly before his death he determined to divide the empire in two, giving to Atahuallpa the former kingdom of Quito, the land of his maternal ancestors, and to Huascar all the rest of the Inca territories. He made his wishes known to the imperial chiefs and exhorted the princes to live in friendship. His embalmed body was transported to Cuzco to take its place with the mummies of the other emperors in the Temple of the Sun; only his heart was preserved in Quito.

This decision was the fatal blow that destroyed the unity of the Inca empire. Not only were the two half-brothers bound to come into conflict sooner or later, as might have been foreseen, but the various ethnic and tribal groups conquered by the Incas were necessarily obliged to side with one or other of the two rulers. Cracks spread with terrifying rapidity throughout the political edifice which had taken the founders of the empire a century to construct. The Cañari, for example, a powerful northern tribe who occupied the area around Tomebamba, declared their support for Huascar and the traditional élite of Cuzco, while a number of groups in the central coastal region pronounced in favour of Atahuallpa.

It seems that the first move in the civil war was made by the northern ruler. Initially he was defeated at Tomebamba and taken prisoner, but managed to escape and return to Quito. There he rebuilt his army under the command of experienced military chiefs who had served under Huayna Capac, and returned to the attack, annihilating the army of his brother and rival on the foothills of the mighty Chimborazo. The town of Tomebamba was stormed and razed to the ground and its inhabitants were massacred. The chronicles of the times describe with great pathos the processions of suppliants brandishing green branches and palm leaves and throwing themselves at Atahuallpa's feet 'with such wailing and such humility as would have broken hearts made of stone' (Sarmiento). Their pleas were in vain: Atahuallpa

ordered the population to be wiped out, 'sparing only a few children and the sacred women of the temple'. It is hardly surprising that the Cañari tribe later became the Spaniards' first allies and lent all their powers to the struggle against Atahuallpa.

In the Cuzco valley, in the spring of 1532, the northerners won a resounding victory over the army of the legitimate Inca. The capital was taken and many high officials, members of the imperial family, were massacred, while Huascar was taken captive. In Cajamarca, where he had remained with a sizeable force of men, Atahuallpa received the news of his triumph. Henceforth, as undisputed ruler, he had the right to wear the scarlet headband, or *llautu*, symbol of absolute power.

In the meantime, Pizarro and his men had landed at Tumbes in April; the town was deserted, having been abandoned at the time of the civil war. At San Miguel de Piura the Spanish founded their first colonial village. Then, in September, leading his small band of soldiers, Pizarro headed for the interior. It was not long before one of his officers, Hernando de Soto, who had been sent on to reconnoitre, made the first contact with an Indian chief or *curaca*. The Spaniards learned that Atahuallpa was to be found with all his court at Cajamarca and that the empire had recently been torn by a terrible civil war that had left deep divisions. At the same time, as they pushed forward, they could see with their own eyes one of the imperial highways, edged with trees, punctuated by the state posting-houses known as *tambos*, and accompanied by an aqueduct that crossed over the ravines by means of spectacular bridges. Everything served to confirm the power and riches of the empire – and also it precariousness.

The sequel is well known: how Pizarro and his men were received by Atahuallpa, the Indians taken by surprise and massacred, the ruler held captive against a huge ranson, which he paid in the vain expectation of recovering his freedom (1,326,539 *pesos* of gold duly accounted for, worth something in the region of fifteen million gold dollars); then the treachery of Pizarro and the assassination of Atahuallpa in a mockery of justice. Even if it is true that one of his last acts was to order the killing of his brother Huascar, nevertheless the appalling death by strangulation of the Inca, after a semblance of conversion to Christianity, remains one of the darkest episodes in the history of the conquest.

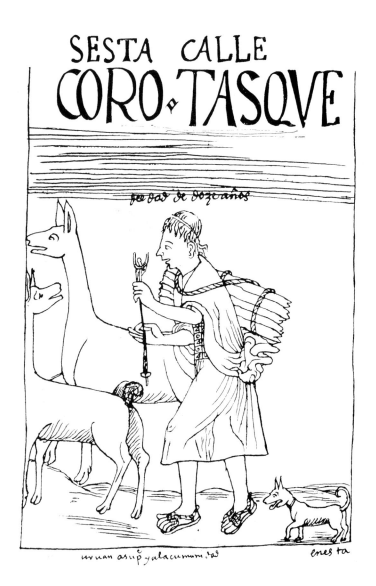

Man spinning, with llamas

SESTA CALLE
CORO·TASQVE

With the two rival princes out of the way, the Spanish continued their march on Cuzco. The capital's inhabitants had remained faithful to Huascar and the imperial dynasty, and in their eyes Atahuallpa was no more than a common usurper. The *conquistadores* met with no resistance. The fabulous treasures of the Coricancha and all the temples and palaces lay before them. Soon greed and ambition would set them at each other's throats; Almagro and Pizarro were destined to meet miserable ends. The third partner, Father de Luque, had died in Panama before he could learn of the exploits and crimes of his two associates.

Like their contemporaries, the Aztecs of Mexico, the Incas were late arrivals on the historical scene. The origins of their dynasty are lost in the mists of legend. The first Sun Emperor, Manco Capac, most probably lived at the end of the twelfth century – but very little is known about the early history, and indeed it is not even certain that he and his sister-wife were real figures. The land of the first Incas did not extend beyond the Cuzco valley itself, and it was not until the reigns of Viracocha Inca, Pachacuti and Topa Yupanqui, in the fourteenth and fifteenth centuries, that the true Empire of the Four Quarters, or Tahuantinsuyu, was established. It lay between the Pacific Ocean and the great tropical forest, stretching along the Cordillera of the Andes from the Ancasmayo River in Colombia to the Maule River in Chile, with a land area as great as that of France, the Netherlands, Switzerland and Italy combined.

The Inca empire lasted barely a century before it foundered under the double shock of civil war and foreign invasion. It would seem that it was itself a successor state which built on the legacy of previous cultures in Peru and Bolivia.

We know that cities and havens of civilized life had existed in the highlands of the Andes, the American 'Roof of the World', and in the coastal valleys, long before the founder of the Inca dynasty had embarked on his predestined march to Cuzco. The pre-Inca cultures left no documents, books or inscriptions for us to read; they did not date their monuments like the Mayas, or keep pictographic records like the Mixtecs. Archaeology is the only means of reconstructing the distant past of the Andes, insofar as it is possible to do so.

ABRIL
CAMAI·IИCAPAIMI

fiesta del ynga

ynca

Looking at the parallels with the Olmec periods of Mexico and Central America, there do seem to be grounds for positing a common 'horizon' for the two great zones of American civilization somewhere between 1500 and 500 BC; it is characterized by the religion of the puma-god of La Venta and Chavín. Maize, which originated in Mexico, spread down towards the south; techniques of working in gold and bronze invented in the south took more than a thousand years to reach Mexico. Over the centuries the two zones diverged and their civilizations took on radically different characters. The highly evolved and complex Mexican calendar, for example, was unknown in Peru, while economic planning and the use of the *quipu* as a statistical instrument had no parallels in Mexico.

The geographical and ecological structure of the coast, which consisted of valley oases separated by wasteland, lent itself to the emergence of a number of separate civilizations; although they shared a high level of agricultural sophistication, employing irrigation and terrace culture, each had a quite distinctive style of its own. These differences are well illustrated by the various artefacts: Mochica ceramics (third century BC to ninth century AD), with their extraordinarily realistic modelling and decoration; Nazca vases with religious motifs and colours which remain vivid even today; the marvellous embroidered cloth of Paracas. Then, on the high plateau, there was Tiahuanaco (tenth century) with its huge monuments and mysterious Gate of the Sun; this was the style that spread, via the city of Huari, down to the coastal regions. At the time when Inca military power began its inexorable process of expansion, the Chimú kingdom, which succeeded the Mochica, was the most important lowland state in the area around its capital Chan Chan. The kingdom submitted almost without a fight.

By the time of the death of Huayna Capac in 1525, Tahuantinsuyu united the coastal and highland peoples within a centralized political and economic framework, in the practice of a common religion and the use of a common language. Over the centuries this prodigious human enterprise has not ceased to arouse admiration and respect; it made an impression even on those who helped to destroy it. One of the *conquistadores*, Mancio Sierra Lejesema, made the following declaration in a testament drawn up in Cuzco in September 1589: 'Let it be known to His Catholic

Majesty that the Incas governed in such a manner that among the Indians there was not a single robber, or vicious man, or lazy man, nor a perverse or adulterous woman . . . that the men had worthy and useful occupations; that the mountains, mines, pastures, game, woodlands and resources of all kinds were duly administered and apportioned . . . that the Incas were obeyed and looked up to by their subjects as most capable beings and experts in the matter of government . . . and may His Majesty graciously understand that I am led to write this account by the desire to relieve my conscience, that by our bad example we have destroyed people as well governed as were these natives.'

Is W. H. Prescott right to see the governmental system of the Incas as 'the most oppressive, though the mildest, of despotisms'? Was Tahuantinsuyu 'a socialist empire', as Louis Baudin suggests, or 'a menagerie of happy men', as it was defined by d'Argenson? The singular genius of the ancient Peruvians astonishes and seduces and shocks by turn. But, whatever one's reactions, one cannot deny the empire its magnificence and its originality.

Like the Indians of Mexico and Central America, the Peruvians believed that four universes, or four 'suns', had preceded our own epoch. Each age had ended in a cataclysm and on each occasion mankind had been wiped out by plagues, fire from the sky or flood. The fifth era was the age of the Incas.

According to the myths collected by the *conquistadores*, the ancestors of the clans (the *Ayllus*) were born from the earth at Paccari Tampu, some sixteen miles south-east of Cuzco. Four brothers and their four sister-wives set out for Cuzco, but only Manco Capac and his sister reached the predestined spot, the 'navel of the world', where a golden rod sank deep into the earth. There the first Inca constructed a hut, later the site of the Temple of the Sun.

The six or seven rulers who succeeded Manco Capac apparently did little more than consolidate the power of the little mountain state around Cuzco. Over the same period the Chanca tribes, who occupied the Ayacucho and Apurimac regions in the north, formed themselves into a militant confederation. When the two budding imperialist powers came into open conflict during the reign of Viracocha Inca, the Chancas pushed forward victoriously

to the capital itself. The emperor's son Inca Yupanqui retrieved the situation, repulsed the enemy and killed their leader. Proclaimed emperor under the name of Pachacute, 'the reformer', he was the true founder of the empire. He is traditionally credited with the rebuilding of Cuzco on a magnificent scale around the Coricancha or Temple of the Sun; the conquest of the Aymara in what is now Bolivia; the extension of his power to the coast; and, most important, the organization of the state. His son and successor Tupac Yupanqui (1471–93) overran the Chimú kingdom, extended the southern boundary to the Maule River in Chile, and built the fortress of Sacsahuaman. Legend also has it that he embarked on a voyage of discovery in the Pacific, from which he is said to have returned with strange black men on board his sailing rafts. It was his son Huayna Capac who further extended the empire in the north; and it was the conquest of Quito that started the chain of events we have already detailed – the birth of Atahuallpa, the partition of the empire and the civil war – which was the decisive factor in the success of the Spanish invasion.

At the height of its power, the Inca empire was a mosaic of different peoples on whom were imposed an administrative dictatorship, a state religion and a common language, Quechua. Unlike the Aztecs, who respected the cultural autonomy of their conquered peoples, the Incas regulated every last detail of the day-to-day life of their subjects, sometimes even resettling entire populations. Their political aim was to impose uniformity on the way of life of the Andean tribes, and in this they succeeded to a surprising degree. Even today the effects are apparent.

The basic unit of the power structure was the *ayllu*, a small rural community whose members had a common ancestry, occupied an area of land called a *marka* and worshipped one or many protective divinities. Depending on the region, these communities either remained relatively independent, like very small democratically run cantons, or joined together in confederations; they might be ruled by military chiefs, the *sinchis*, or by hereditary rulers, the *curacas*.

It was the patient toil of the Indian peasants over the centuries that transformed the landscape of one of the most inhospitable regions of the world. At the cost of immense effort they constructed agricultural terraces on the steepest mountain slopes

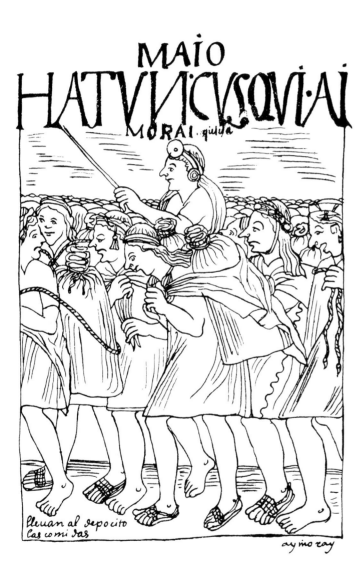

and dug canals stretching tens of miles, where necessary spanning ravines by means of aqueducts and tunnelling through mountains. From a wild tuber they developed the potato, nurturing and experimenting until they had some seven hundred different varieties. They cultivated Andean rice (*quinoa*), maize, beans, peppers and the avocado pear, and used the *guano* of the coastal isles as fertilizer. In addition they were the only people in the continent of America to domesticate two animals that served both for wool and meat, the llama and the alpaca; the llama was also used as a beast of burden, although not very well adapted to the task.

When a conquered province came under Inca rule, the first act of the imperial administration was to take stock of its resources in terms of land, manpower and herds. One part of all fertile land was assigned 'to the Sun', which is to say that its profits went to the temples and priests, a second share was made over to the sovereign, and what was left remained the collective property of the *ayllus*. Practically all the herds of llama and alpaca became the property of the Sun or the Inca: the wool was then distributed among the peasants, the production of cloth being subject to severe restrictions. But probably the greatest asset of the imperial state was the manpower it had at its command: the system of forced labour provided the ruler and his officials with vast human resources for use in mining, road-building and the construction of fortresses. Tradition has it that thirty thousand men were employed in building the fortress of Sacsahuaman.

The whole population was divided into ten categories, according to age and sex: men of between twenty and fifty were liable to be mobilized for forced labour, the women were the weavers, and the children and old people undertook all the light work. In operating such a system it was vitally necessary to have an accurate assessment of material and human resources. Hence the statistical tool known as the *quipu*, a device made up of a number of knotted cords which was used by specially appointed officials, the *quipucamayocs*, to make a census of men, goods, animals, weapons and so on; the method of counting was based on a decimal system.

In theory at least, each group of 10, 100, 500, 1,000 and 10,000 families came under the control of an official of the government.

Ritual ploughing

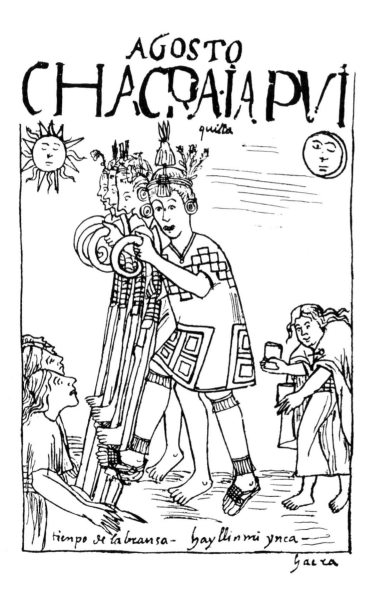

AGOSTO
CHACRAIAPVI

quilla

tiempo de labransa — hayllinmi ynca —

yacta

In practice it is not easy to see how such a strict mathematical system could be applied to a variety of rural and urban societies, but certainly the whole population was contained firmly within a hierarchical bureaucratic network which controlled and directed all its activities. The *curacas* or chiefs of the subject provinces had to travel to Cuzco once each year to give an account of their stewardship, at the same time bringing presents of gold and silver for the Inca. Above them in rank came the governors, who were of noble descent, and above the governors were four *apos* or viceroys, directly related to the Inca. Being of royal blood and therefore descended from the Sun, all these high officials wore as an emblem of office huge golden ear ornaments, which gave rise to the nickname of *orejones* ('big-ears') bestowed on them by the Spaniards. Then, to complete the totalitarian apparatus, there were the 'inspector-generals' or *missi dominici*, who were invested with the power of the sovereign and travelled through the provinces to head official enquiries and oversee the work of the civil servants.

It is clearly unwise to compare the socio-economic system of the Incas, the expression of a civilization that possessed no written language and was essentially an agrarian society, with our modern states. Words can set a trap for the unwary. Peruvian 'socialism', if that is what it was, was rooted in a vigilant despotism whose benevolent and paternalistic aspects ought not to blind us to the absolute character of its power over the subject Indians, the cruelty of the punishments it inflicted on disobedient subjects, the huge profits diverted from the people to the military and ecclesiastical aristocracies, or, finally, the very common practice of enforced migration of whole populations, massive deportations whose victims, the *mitimaes*, risked the severest reprisals if they attempted to return to their homelands.

In return for total obedience the Inca state guaranteed security, and this it most certainly provided: the stores of food removed all danger of famine, the army was there to protect the peasants, and theft was practically unknown. Depending on how you choose to look at it, the empire can be seen either as a huge force of tightly disciplined slaves or as a large, virtuous and wisely managed family. In reality no doubt these apparently contradictory views are both justified, and indeed complementary.

The state religion was one of the principal means by which the Incas cemented the unity of their empire. Its main feature was the divine worship of the Sun, or Inti, the ancestor of the imperial family, ruler in heaven as the Supreme Inca, or Sapa Inca, was ruler on earth. But it is important to note that the Sun-cult did not preclude the worship of local divinities or the sacred objects, the *huacas*, that were regarded as holy things by the people.

After the Sun, at the head of the Inca pantheon, came his sister-wife the Moon, and the Thunder. In the great temple at Cuzco these three divinities were worshipped side by side. As with the Mexican god Tlaloc, it was on the mountain peaks that the faithful used to invoke the Thunder, god of life-giving rain.

This official religion was furnished with an extensive priest-hood, sumptuous temples, 'convents' where 'chosen women' devoted themselves chiefly to weaving extremely beautiful clothes for the emperor, and with lands and herds whose revenues were administered by the priests.

Imposing the cult of Sun-worship on all their conquered provinces effectively ensured that the Incas were accorded the heartfelt reverence due to their dynasty. It was a political act. But for the Incas themselves, or at least for a small élite from the times of Pachacute onwards, another divinity took pride of place, eclipsing even the Sun. This was Viracocha, the Creator and Civilizer, to whom were addressed poetic hymns couched in elevated and abstract terms. For the ordinary people the reverse was true, and minor deities and spirits abounded, taking material form as *huacas* and protective fetishes or *conopas*. Fountains, grottoes and rocks were regarded as sacred.

The cult of the Sun was celebrated at Cuzco with great magnificence, in the presence of the emperor himself. More than four thousand priests and fifteen hundred *aclla cuna* ('sun virgins') took part in the ceremonies, which included the sacrifice of llamas, libations of *chicha* (maize beer) and offerings of food, figurines of precious metal, and cloth. Human sacrifice, although not practised on the same level as in Mexico, was occasionally resorted to when some catastrophe or pressing danger threatened the community. The victims were either children or 'sun virgins'.

The High Priest of the Sun and his principal assistants belonged to the imperial family. In this way a link was created between

church and state, essential for an autocratic régime in which heaven itself played a part in the power structure of government.

The ancient Peruvians appear not to have been greatly interested in observing the movements of the stars or in the measurement of time. They had nothing comparable to the *tzolkin* or 'long count' of the Mayas, and seem to have managed with an approximate combination of the lunar and solar years. Without writing, they were unable to pass on the knowledge acquired from generation to generation, except through the memories of the *amautas*, or wise men, whose task it was to teach the members of the noble families everything necessary to their functions: laws, customs, rites, traditional history. As well as the *amautas* there were court poets, or *harauecs*, who evoked the most important events of previous reigns in their poetic chants. It has to be admitted that the intellectual stock-in-trade of the Inca élite was limited. Education was in any case restricted to the nobility. 'One should not teach the sons of plebeians that which concerns only the nobles,' said Tupac Inca Yupanqui. 'For them it is sufficient to learn the trades of their fathers; command and government are not the concern of the people.' This aristocratic concept of knowledge was combined in the Incas with a very pragmatic cast of mind, reflected in the utilitarian architecture, of grandiose proportions but utterly devoid of originality or imagination. The Incas were engineers rather than artists, and explored every area of practical knowledge: nothing is more characteristic of them than the communications network with which they equipped the empire.

One of the greatest surprises that greeted the Spanish when they arrived in Peru was to find themselves looking at roads the like of which was unknown in Spain, and probably throughout Europe, at this time. Yet the Indian engineers must have overcome the most appalling difficulties in constructing these imperial highways: in the coast region there was shifting sand, in the highlands there were cliffs, torrents and the glacial *puna* wastes. They nevertheless had the skill to hew out passages in the solid rock, build retaining walls, and cross ravines. Inca roads were as straight as possible, climbing in steps up mountain slopes, going through or over any obstacles rather than round them. In the plains, according to the Spanish, they were wide enough to accom-

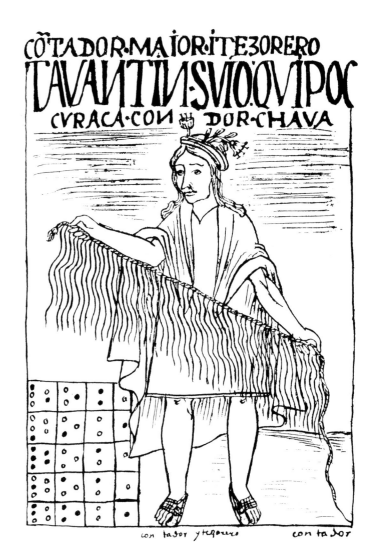

Spanish ship

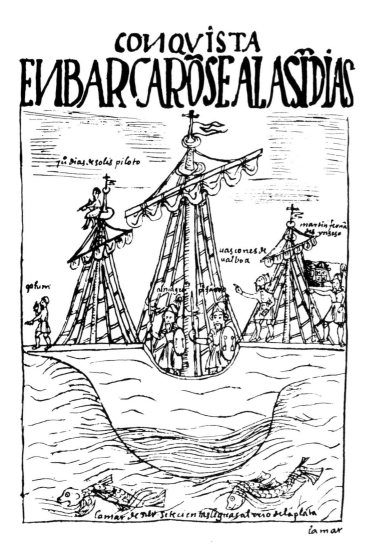

modate eight horsemen riding abreast. Where sand threatened to cover them over they were marked out with posts. And in the very hot areas canals ran alongside the roads to provide water, and trees were planted at intervals to give shade.

Bridges made of wood, stone or *hamac* – extraordinary cable networks suspended over chasms – permitted wide rivers and mountain torrents to be passed in safety. Sometimes ferries were used, in the form of rafts made of tree-trunks or planks with gourds to give buoyancy.

The overall road plan reflected the topography, the division of the country into the coastal strip and the Cordillera. The coast road started at Tumbes, passed through Chimú, Pachacamac and Nazca, and then struck up to Cuzco before running down along the Pacific coast towards Chile and the Atacama Desert in the south, by way of Arequipa, Arica and Tarapaca. The mountain road also passed through Cuzco, linking it with Cajamarca, Tomebamba and Quito in the north, and with Lake Titicaca and Chuquisaca in the south. Secondary roads connected these two approximately parallel highways, so that when the Inca travelled through the provinces the coastal or highland officials could join him at each stage of the journey. It has been estimated that the entire network comprised some ten thousand miles of roads. It is an astonishing figure, and has led one eminent anthropologist, Alfred Métraux, to speculate whether there was not some 'element of gratuitousness, or more precisely of excess, that could be accounted for only by the vanity of despotic rulers with veritable armies of workmen at their disposal'; he regretted 'the prodigality with which the sovereigns of Cuzco spent and indeed wasted their greatest asset: the strength, patience and time of the *hatun runa*, the Andean peasant'.

It is evident that the roads were primarily intended to serve a strategic function. They enabled the sovereign's armies to intervene at any moment, and with amazing speed for that period of history, if it was necessary to put down a rebellion or repel an invasion. News and messages could be transmitted between Cuzco and Quito, and between the capital and the southern frontier, by means of a courier system organized on similar lines to the Dromos of the Byzantine empire. The messengers or runners, the *chasquis*, were renewed at approximately three-mile intervals.

Normally they carried information, either verbal or contained within a *quipu* (sometimes accompanied by a red thread taken from the emperor's headdress), but on occasion they might transport such things as fish or game for the nobles' tables. It would take about ten days for a message to travel the fifteen hundred miles from Quito to Cuzco.

The *tambos*, a sort of caravanserai placed at regular intervals along the route, served as rest-houses for travellers. Given the social and economic structure of the empire, there is no reason to believe that the roads and *tambos* were used by anyone other than the official services and personnel – civil servants, *quipucamayocs, chasquis,* soldiers, senior dignitaries and the Inca himself. This was the infrastructure of imperial domination. Apparently ancient Peru had no bands of travelling merchants such as the *pochtecas* of Mexico, who were of considerable importance at about this period; presumably it was because of the state monopoly of all economic transactions that there is no reference to these caravans of travellers in any of the chronicles. But we do know that there were Peruvian sailors capable of voyaging along the Pacific coast in their huge sailing rafts. The Spanish navigator Ruiz encountered one of these craft to the south of Panama; it was laden with valuable merchandise and travelling north. Undoubtedly vessels of this type were capable of reaching the south-west coast of Mexico, and were responsible for the spread of Peruvian techniques for working in gold.

The great British historian and philosopher, the late Arnold Toynbee, is well known for his 'challenge and response' theory of history. He believed that any civilization is built up and perfected in response to a challenge posed by nature or mankind; the greater the challenge, the stronger the civilization is likely to become, unless of course it succumbs in face of the obstacle. The natural environment of the Andes is one of extreme harshness, with giddy mountain heights and plateaus, cold temperatures, thin atmosphere, poor soil and erosion. One has only to imagine American man of pre-Columbian antiquity pitting himself against these inhospitable regions, alone, without ploughing animals or machines, to see that the Peruvian Indian had no choice but to surpass himself or go under. In the event his response to the challenge was to build a civilization as austere as the *sierra* and the *puna*, ruled by the cold intelligence of an élite conscious of its mission.

The Olmecs and the Mayas also responded to the challenge of natural phenomena no less hostile to man, but in their case it was humid heat and luxuriant growth they had to contend with, and their civilization is marked by their totally different environment. Nothing could be more of a contrast than the megalithic and undecorated achitecture of the Incas, on the one hand, and, on the other hand, the exuberantly rich bas-reliefs and stuccos which spread a continuous filigree of pattern over the façades and pillars of the ancient cities of Mexico. And there is a similar contrast between the mathematical organization of economic life, the uniformity of belief and custom and the destruction of vernacular languages that characterized the Inca empire, and the chaotic and often contradictory profusion of city-states in Mexico, even under the Aztec empire.

One does not need to invoke theories of climate and psychology in order to recognize that the extraordinary physical surroundings of the Andes must have played a large part in shaping the extraordinary culture of the Incas. And it is no great surprise to learn that the mountain peoples of the Peruvian highlands were easily victorious over the inhabitants of the oases and comfortable towns on the Pacific coast.

At all events, the Incas have left their mark on the lands they occupied, in Peru and Bolivia, in Ecuador to the north and down into Argentina and Chile – and that in spite of the short rule of the Sun Emperors. Quechua, which supplanted innumerable languages and dialects formerly spoken in the empire, is today the tongue of six to eight million Indians, the *runa-simi* or 'tongue of men'. Only Aymara, the old language of Tihuanaco, has survived alongside the imperial tongue; today it is spoken by something like one million people.

The *ayllu* still survives. These ancient agrarian communities existed long before the Incas took them over and made them part of the social structure of their empire; today they take the form of *comunidades*. The Catholic religion, embraced in good faith by the Indians, has become entangled with the remnants of ancient native cults: the people have not forgotten the Sun, Inti Huayna Capac,

Death of Atahuallpa

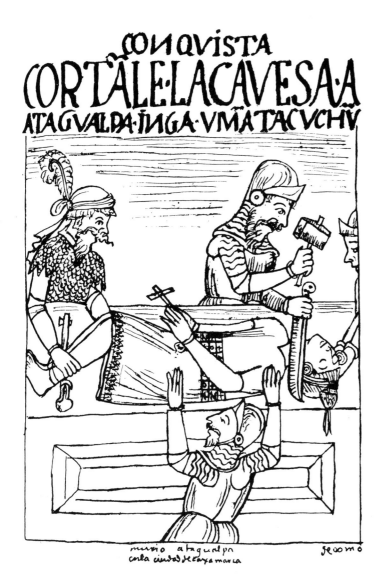

who is identified with God and Christ; nor the Thunder, Illapa, identified with St James; nor the Pacamama, the Earth, who has become an aspect of the Virgin Mary. Indian syncretism is practised in certain fertility rites calling on supernatural forces to give their blessing to the coming harvest. The *huacas* continue to be regarded as sacred objects, and there is a frequently used form of worship that includes a number of traditional features, in which offerings laid out on *mesas* are made to mountains, rocks and lakes. And, in contrast to developments elsewhere in America, the pentatonic scale of pre-Columbian music survives in something like its original form in modern Peru and Bolivia.

The Inca tradition lives on as one of the many influences acting on Andean America and determining its often turbulent development; it should not be underestimated. Unless it is taken into account it will never be possible to find a lasting solution to the Indian problem, which is, in its turn, part of the larger question of agrarian reform.

José Vasconcelos may or may not have been right when he prophesied that Spanish- and Portuguese-speaking Indo-Latin America would be the crucible from which 'cosmic man' would one day emerge. It is impossible to say. But we can be sure that the magnificent landscape, imposing remains and tenacious people of what was once the land of the Incas will have a prominent part to play in the continent's future.

Jacques Soustelle

Illustrations

1 Paracas cloth found in the desert near Pisco, 125 miles south of Lima. Third century BC.

2 Golden idol, now in the Lima Museum. Few objects of worth escaped the ravages due to the gold-lust of the Spanish conquistadores.

3 Geyser at Tatio, northern Chile, at an altitude of nearly 15,000 feet.

4 The valley of Vilcanota, seen from Machu Picchu. Here the cold winds from the Andes meet the hot winds blowing from the virgin forest.

5 Ruins of the extraordinary Inca city of Machu Picchu, over 8,000 feet above sea level. Never located by the Spanish, it was discovered in 1911 by the American Hiram Bingham.

6 Part of the city of Machu Picchu, seen from the summit of Huayna Picchu.

7 The carved rock of Intihuatána, a masterpiece of Inca stonemasonry and the centre of religious life at Machu Picchu. Little is known about the nature of the ceremonies practised here.

8 The ramparts of the fortress of Sacsahuaman, near Cuzco. The biggest blocks of stone are ten feet high; thirty thousand men were employed in its construction.

9 Terraces at Moray used by the Incas for agriculture, in conjunction with an extremely efficient irrigation system.

10 In the early morning mists of the Cuzco region, peasants go up the mountainside to their potato-fields, situated at an altitude of 13,250 feet.

11 This tool (called a taclla in Quechua) still serves as a plough for the peasants of the Andes.

12 Peasants preparing to plant potatoes, at a height of 14,450 feet.

13 Indian hamlet in one of the many valleys of the Andes. Most peasants live alone or in small groups, very few in villages.

14 Terraces at Pisac. The Indians still use these tracks and terraces built by their ancestors, the Incas.

15 Pisac. It was, and still is, an immense labour to cultivate these hostile mountain slopes.

16 The peasants of today live in the Inca palaces of Ollantay Tambo.

17 The walls constructed by the Incas have survived earthquakes; the Spanish used them to provide foundations for their churches and palaces. Here, a street in Cuzco.

18 The Inca highway near Copacabana in Bolivia. A network of some ten thousand miles of roads permitted the Inca to govern from Cuzco, in the centre. Many sections of these roads are still used today, and a large number of modern roads follow the ancient routes.

19 The fortress of Sacsahuaman. The sacred llama was the only beast of burden available to the Incas, and could carry loads of up to 66 lb.

20 Road in the Inca village of Ollantay Tambo.

21 Indians going to market, using the old Inca paths.

22 In the mountains of the province of Cañas, a peasant woman spins alpaca wool while guarding the herd.

23 Peasant girls at a cattle market near Ayacucho.

24 In certain areas of Peru, donkeys, mules and horses imported by the Spanish have replaced the llama. These were photographed in the Ayacucho region.

25 Aymara woman practising magic in her village.

26 The celebration of a native rite, calling on the gods to bless the harvest, in the mountains over the Apurimac valley, Canas province.

27 Harvesting on the shores of Lake Titicaca, 12,500 feet above the sea. It was the Spanish who introduced wheat to Latin America, while Europe owes maize, the potato and the tomato to the Indians.

28 Fields of cereal crops in the Tiahuanaco region. The peasants in these areas have no machines to help them.

29 The Bolivian altiplano, a vast plateau at an altitude of 14,440 feet; in the background, the Cordillera of the Andes. To the right is Mount Illimani, which rises to 21,500 feet.

30 Stormy sky near Cuzco.

31 The Indians regard the condor as sacred. It has a wing-span of nearly ten feet, and is rarely seen in the open spaces of the Andes.

32 The monumental entrance to the Temple of the Moon at Ollontay Tambo.

33 Six granite monoliths, over thirteen feet in height, forming part of the unfinished Temple of the Moon. They date from the late period of Inca architecture.

34 The Rock of Suchuna, throne of the Inca, faces the citadel of Sacsahuaman. According to legend, it was on these steps that the Inca and his nobles sat to watch the festivities.

35 Six examples of Inca stonemasonry techniques:

Flight of steps at Machu Picchu.
Hollowed-out rock path near Machu Picchu.
Irrigation canal near Cajamarca.
Detail from the Temple of the Moon at Ollontay Tambo.
Water conduit at Tampu Machy, known as 'the Bath of the Incas'.
Tomb hollowed out of the rock, near Cajamarca.

36 Inca roadway and the mighty walls of Sacsahuaman.

37 Suspension bridge, constructed according to Inca techniques, spanning the Apurimac River. Each year the bridge of plaited grass is rebuilt as part of a festival. In this way the last keshwa chaca has survived to the present day.

38 This bridge is used only by travellers on foot. In Inca times there were hundreds of bridges of this type, but much wider and stronger. The conquistadores were able to ride across them on horseback.

39 Arable land is rare; these peasants have built their house on rock.

40 Floating village of the Ourou Indians on Lake Titicaca. This collection of huts is built on thick mats of reeds. The Ourou live mainly by fishing and hunting.

41 Ourou woman in her balsa boat on Lake Titicaca, at an altitude of 12,500 feet.

42 The Ourou Indians rarely set foot on dry land; they live on their floating islands and in their balsa boats.

43 The Ourou setting out for Puño to take part in the Sun Festival.

44 All Indians in the Andes wear hats. The variety is endless; these pages show no more than a few examples. Each village and region has its own style. At festival time they are decorated with additional flowers and feathers.

45 Market at Pisac, in the sacred valley of the Incas. The Indians live scattered over a wide area, and the markets are their meeting-places.

46 The market-women of Cuzco are instantly recognizable by their big white hats.

47 Scene after the purchase of an earthenware jar in the market at Otavalo, Ecuador.

48 The market is largely a female preserve, but there is one exception: the men of Otavalo sell the ponchos and blankets they have woven themselves.

49 A market-woman from Cuzco sells oranges at Chinchero. In the high valleys of the Andes fruit is something of a rarity.

50 Scenes from the markets of Cuzco and La Paz. A special kind of loaf, decorated with a head, is baked for the Day of the Dead and eaten at the cemetery.

51 Indian drugged by excessive chewing of coca leaves. Conditions of life are so harsh that the men who work at high altitudes use coca-chewing as a tonic.

52 Indian pharmacist's stall at La Paz. The Indians have a wide knowledge of herbal remedies. The plants come from widely differing climatic regions – the high mountain lands, the virgin forest and the sea. Llama embryos are used to ward off evil spirits.

53 The Indians of Tarabuco, near Sucre in Bolivia, are easily recognized by their leather helmets. They stay in the wilds and are very suspicious of outside influences.

54 Isolation and suspicion have helped to preserve many old traditions among the Tarabuco.

55 Flight of cormorants on the Pacific coast. In Inca times the Indians used to travel hundreds of miles from the interior to collect guano on the islands; this would be used as fertilizer for their agricultural terraces. For most of the year the coast is shrouded in fog; it never rains. The area is desert wasteland.

56 The Inca road passed through vast open spaces such as the Atacama Desert in northern Chile, near the frontier with Bolivia.

57 Andean valley in northern Argentina.

58 Woman weaving in the Atacama Desert.

59 Every town and village in the Andes has its festival. Musical instruments of Indian origin are seen side by side with those imported by the Spanish. Indian music plays an important part in the life of the Andean peasant.

60 Young woman of Pisac dressed for the festival.

61 Village festival on the shores of Lake Titicaca.

62 Ourou musicians relaxing during the festival at Puño.

63 Mass at Chinchero. The Spanish destroyed the Inca temples, but the walls were often used for building churches.

64 Village church on festival day in a mountain valley near Huancayo.

65 *View from Machu Picchu. The Vilcanota River winds through the Andes towards the Amazon.*

66 *One of the Spaniards' first concerns was to convert the Indians to Christianity. They built churches and monasteries even in the most out-of-the-way spots. This church is near Moray, above the valley of the Vilcanota River.*

67 *Doorway of Cajamarca cathedral, built on the foundations of the Sun Temple. It was here that the last Inca, Atahuallpa, was executed by the Spanish* conquistadores.

68 *A child's funeral procession near Cajamarca.*

69 *Narrow street in Cuzco reminiscent of Andalusia.*

70 *Cuzco, the 'navel' of the Inca kingdom, has been transformed into a Spanish town; all the buildings in the centre rest on foundations dating back to the Inca empire.*

71, 72 *Procession of Our Lord of Miracles in Lima.*

73 *Although peasant life has remained almost unchanged over the centuries, in the towns the past and the industrial age meet face to face. Class divisions have rapidly widened and are becoming intolerable. Only a tiny minority of Indians have any political influence. Non-Indian military régimes hold power in the various countries of the Andes. All the lands that belonged to the ancient kingdom of the Incas are rich in raw materials, minerals and oil, but up to now the Indians have benefited hardly at all from this wealth. Conditions for miners are appalling.*

74 *The Spanish destroyed Indian culture and exploited the people and their resources. The result is a profound suspicion of the white race.*

1

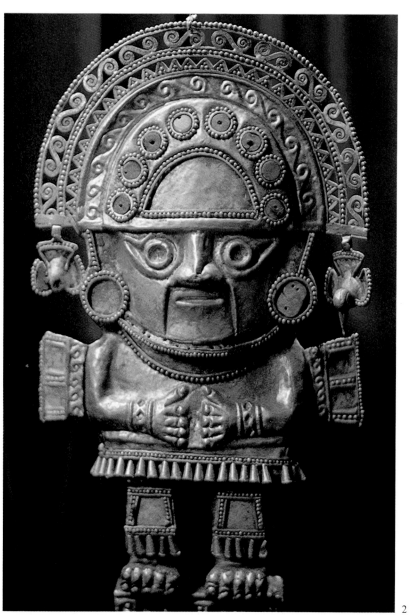

2

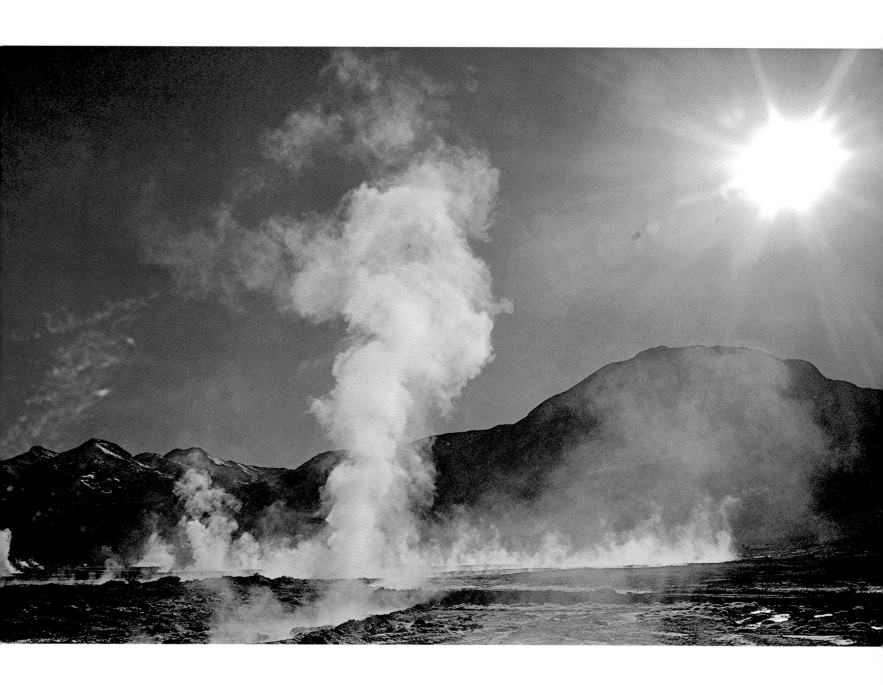

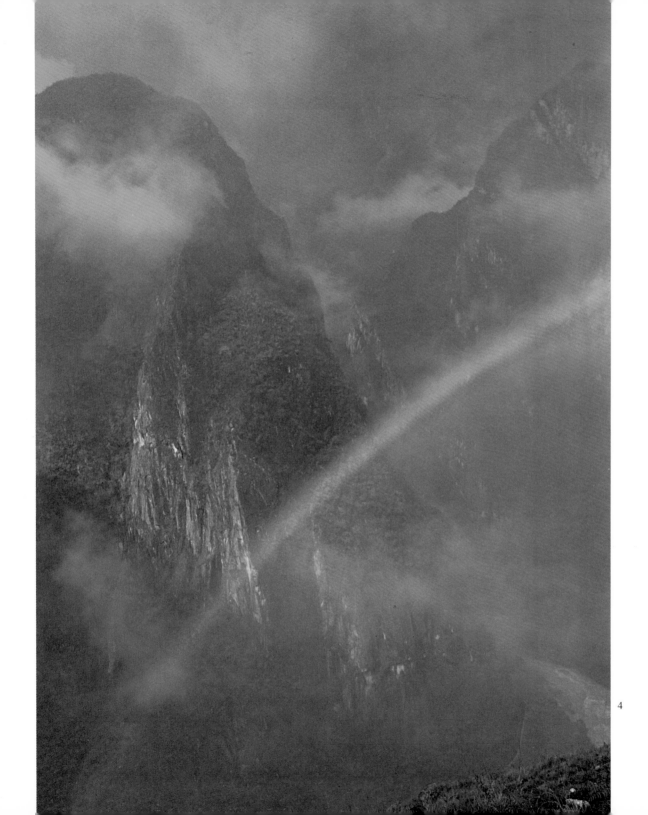

4

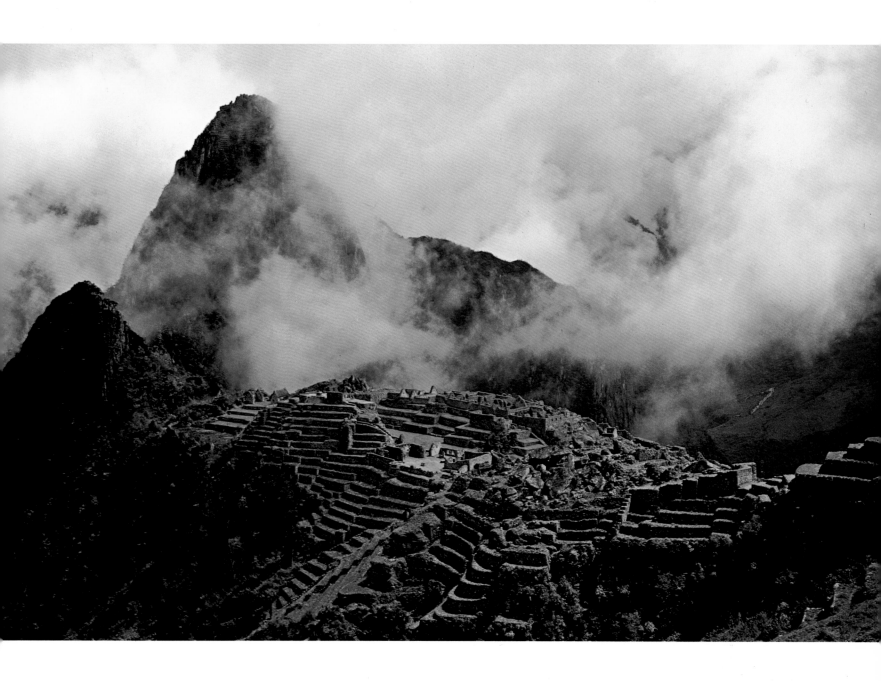

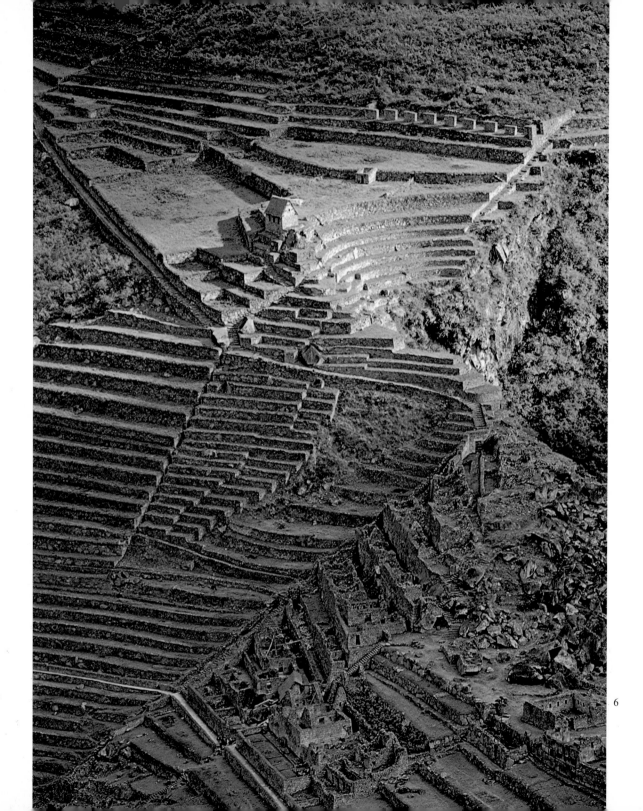

6

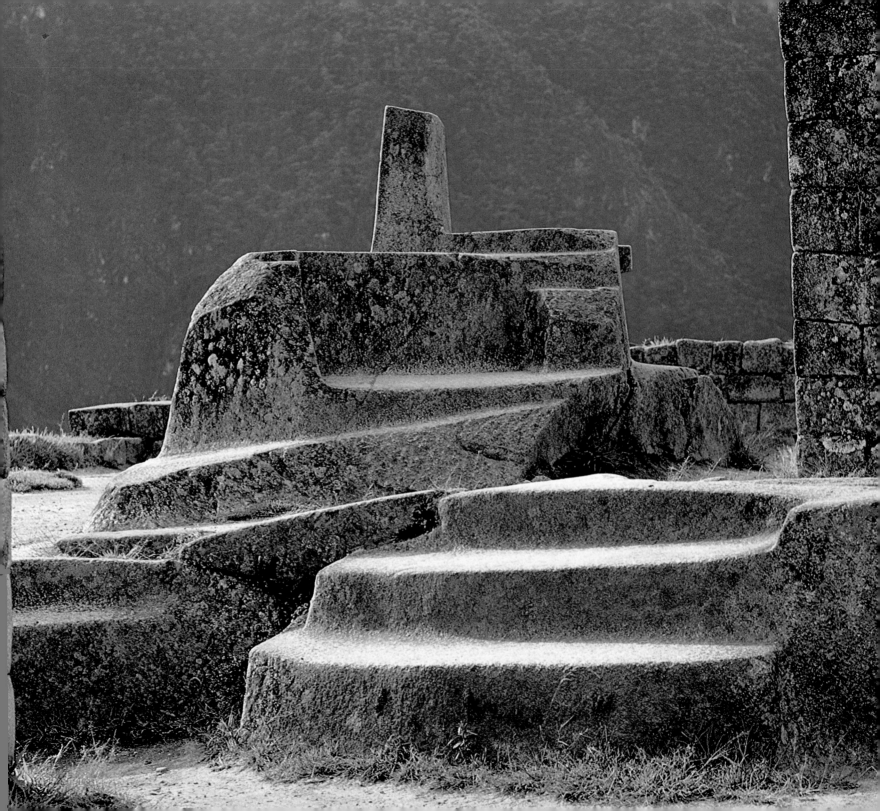

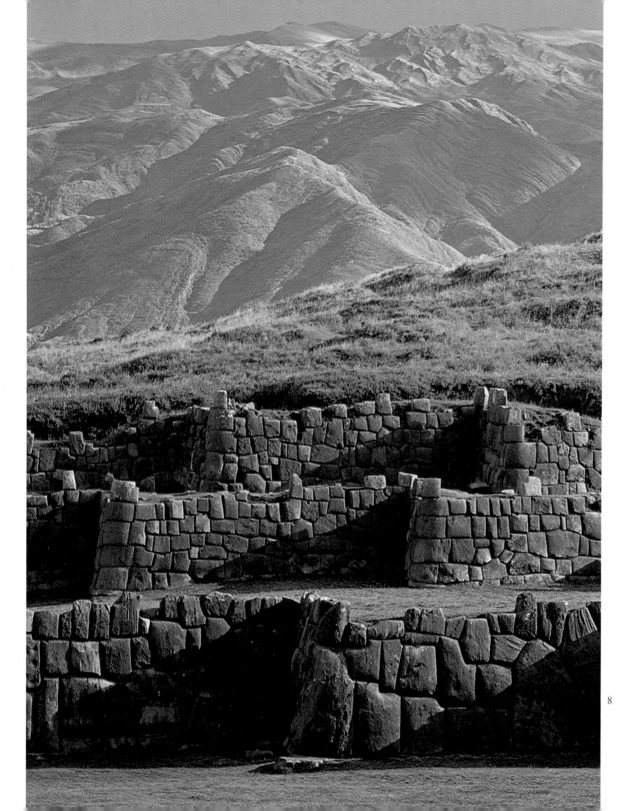

8

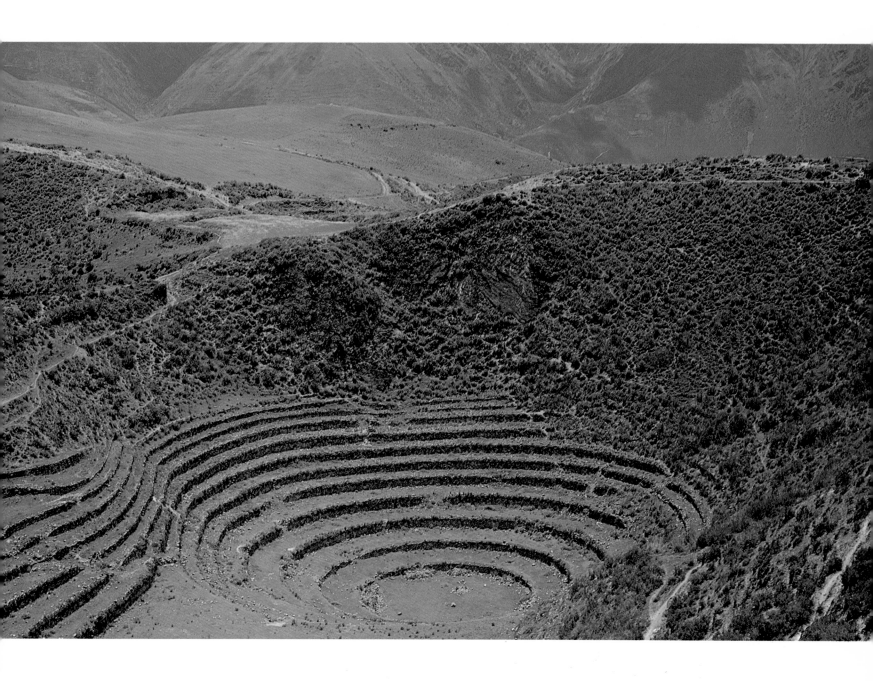

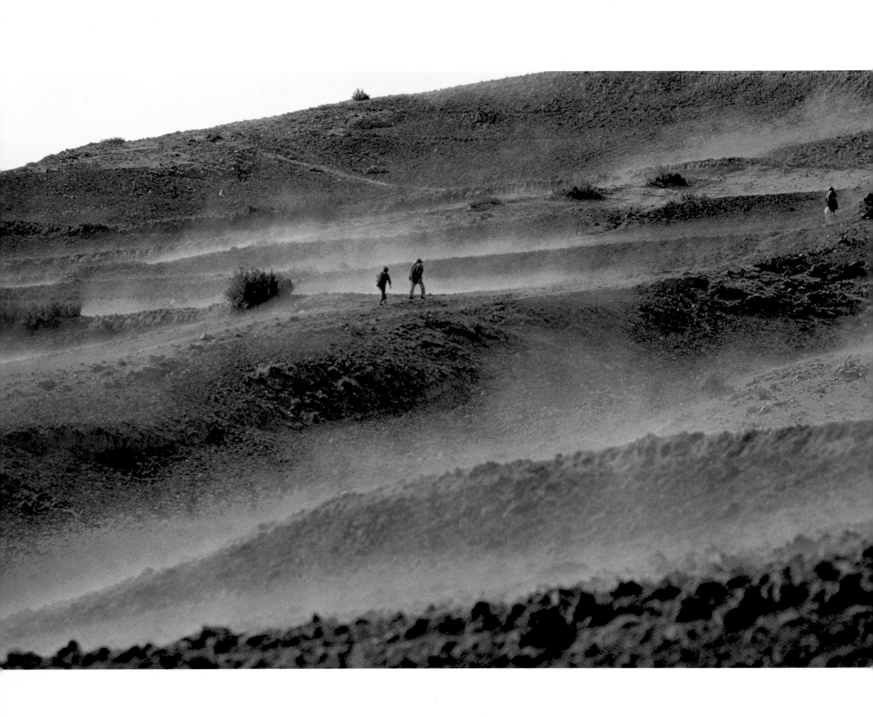

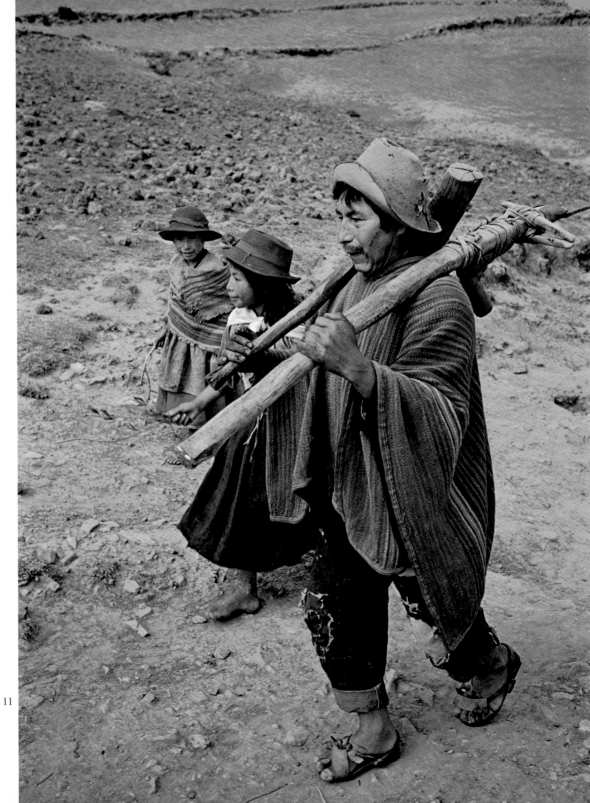

11

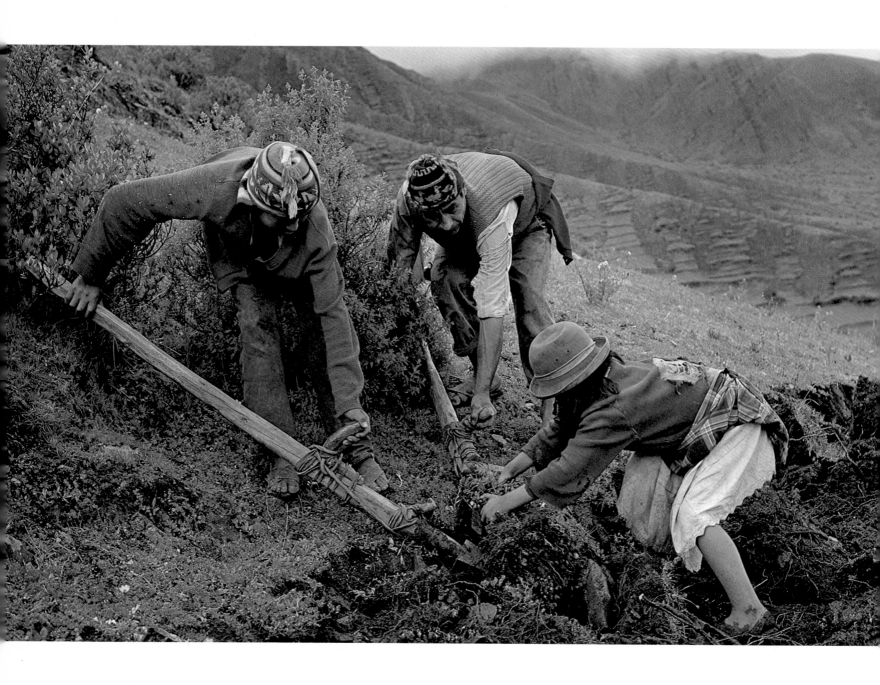

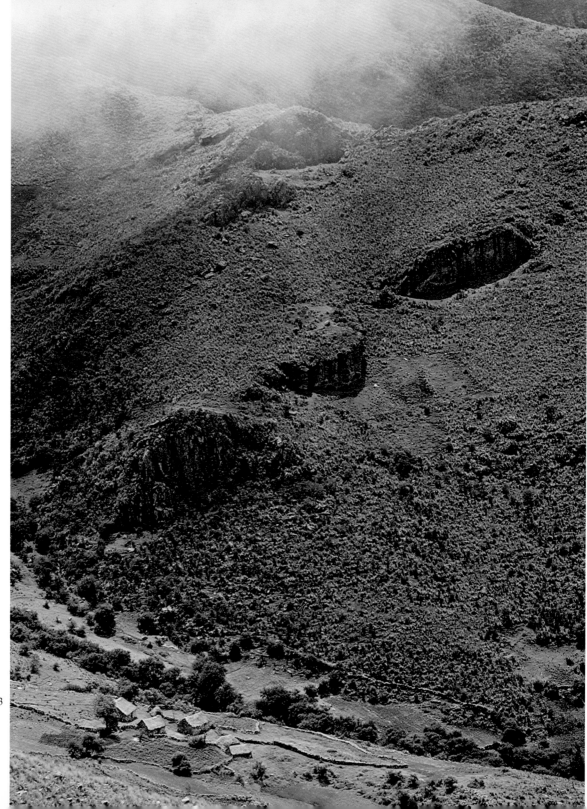

13

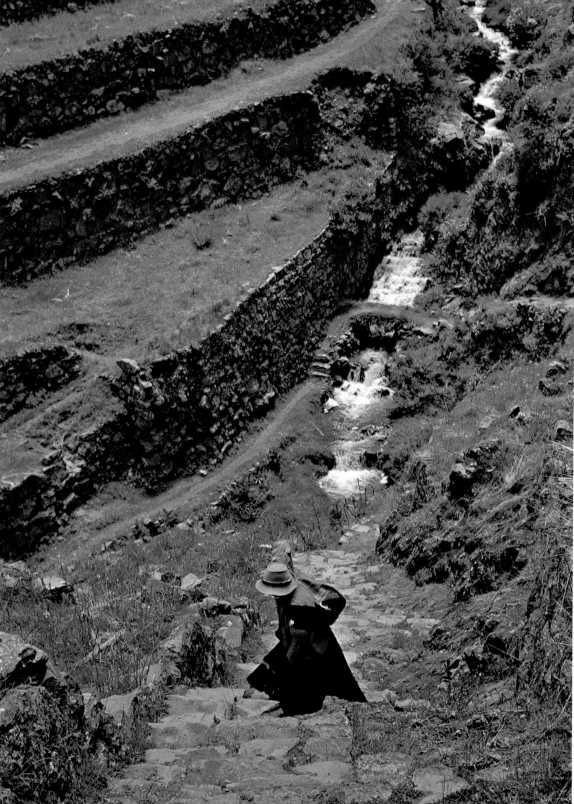

14

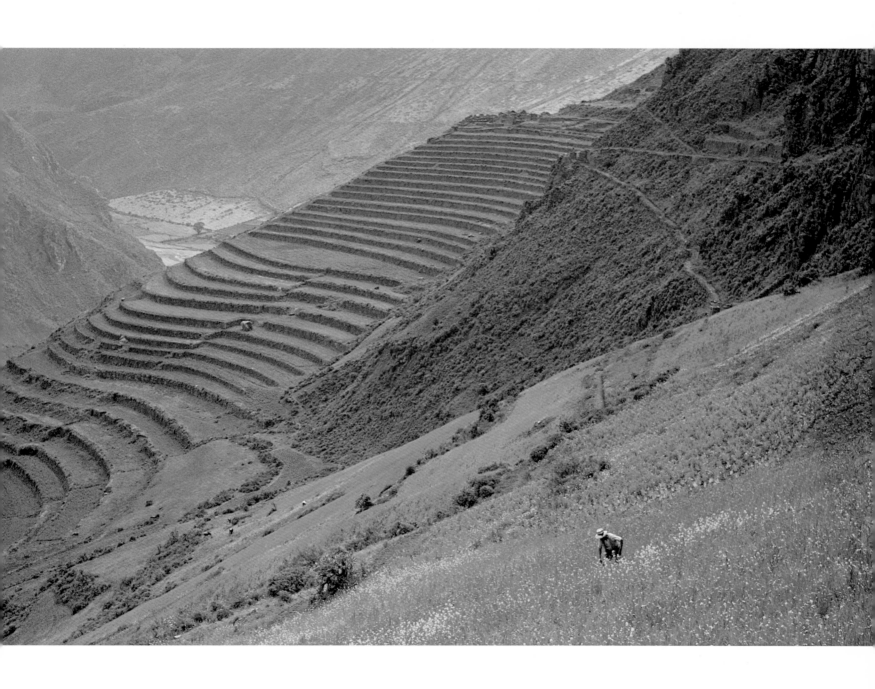

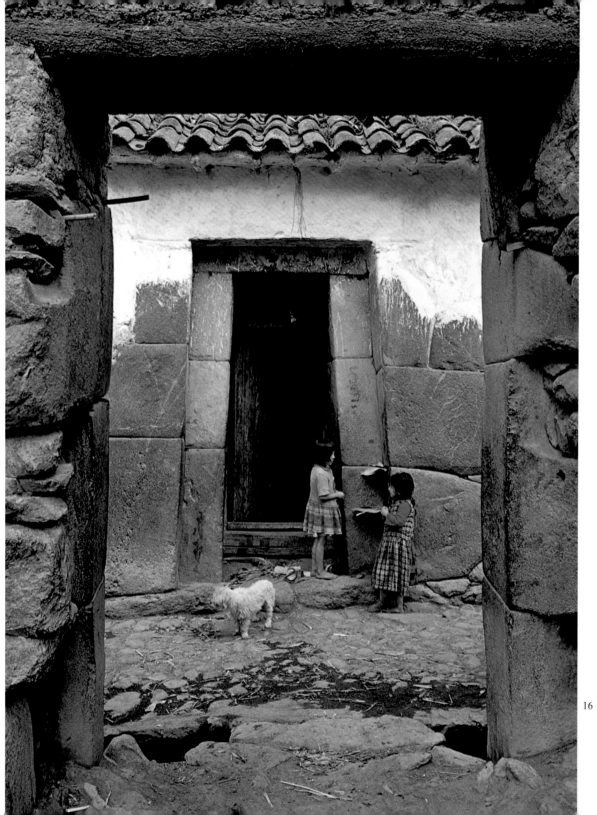

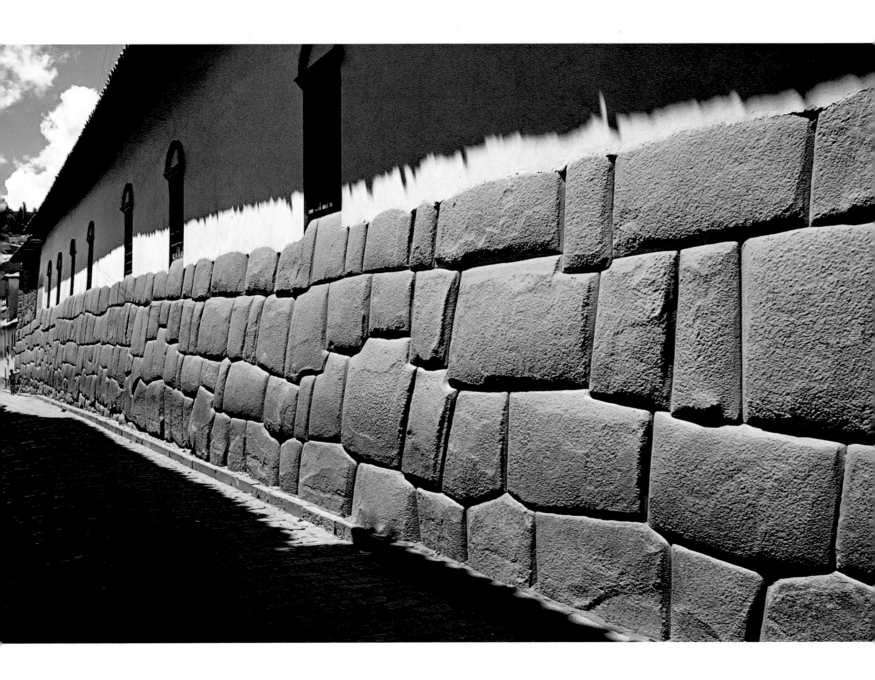

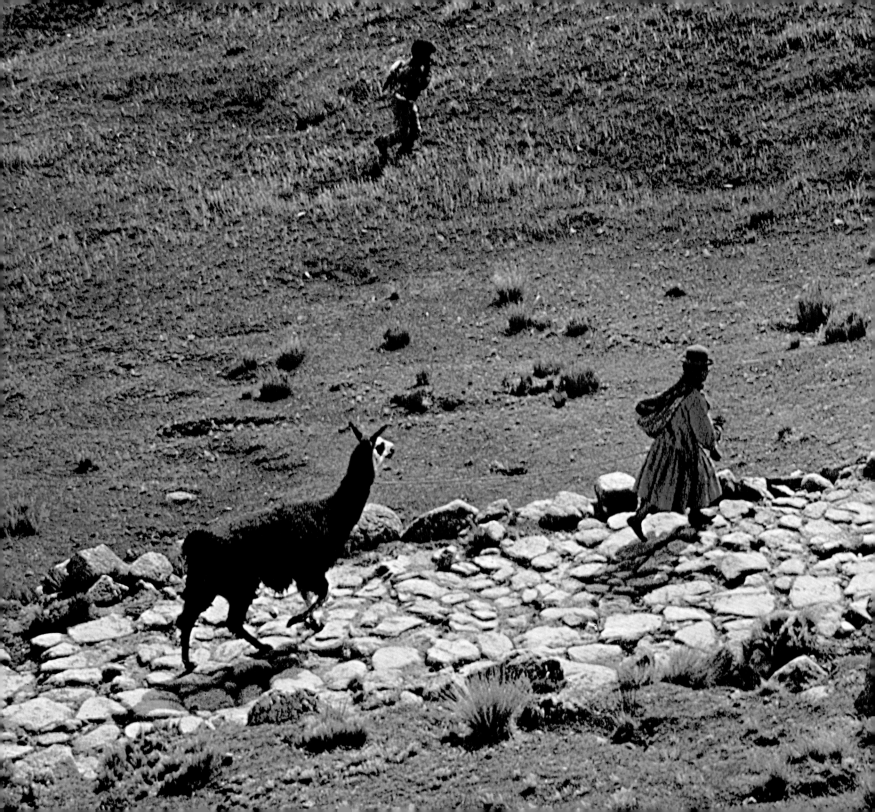

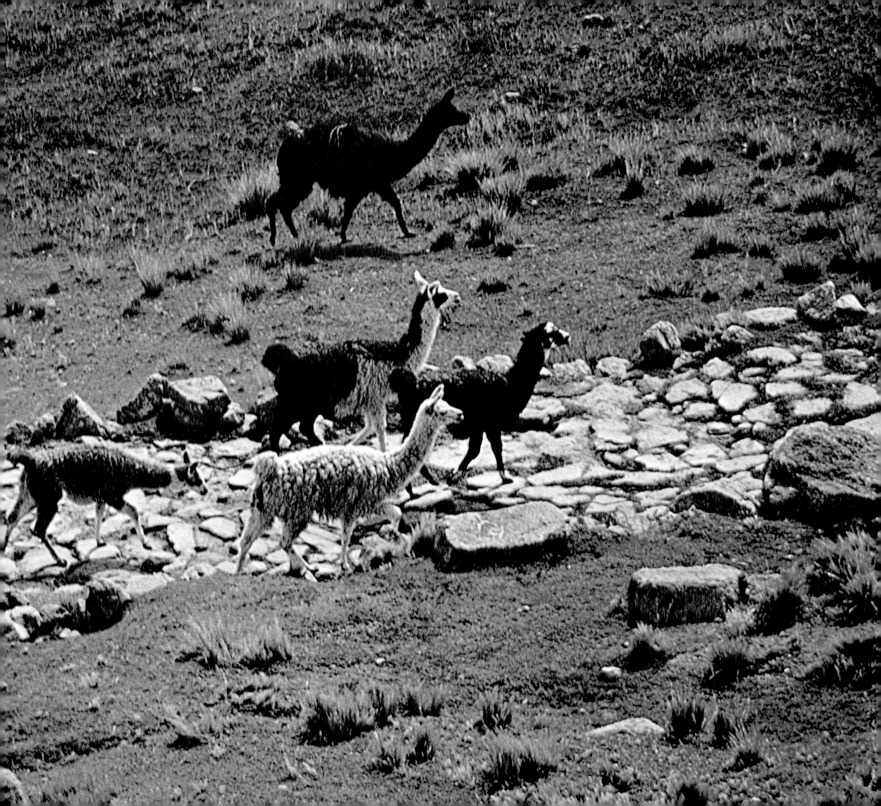

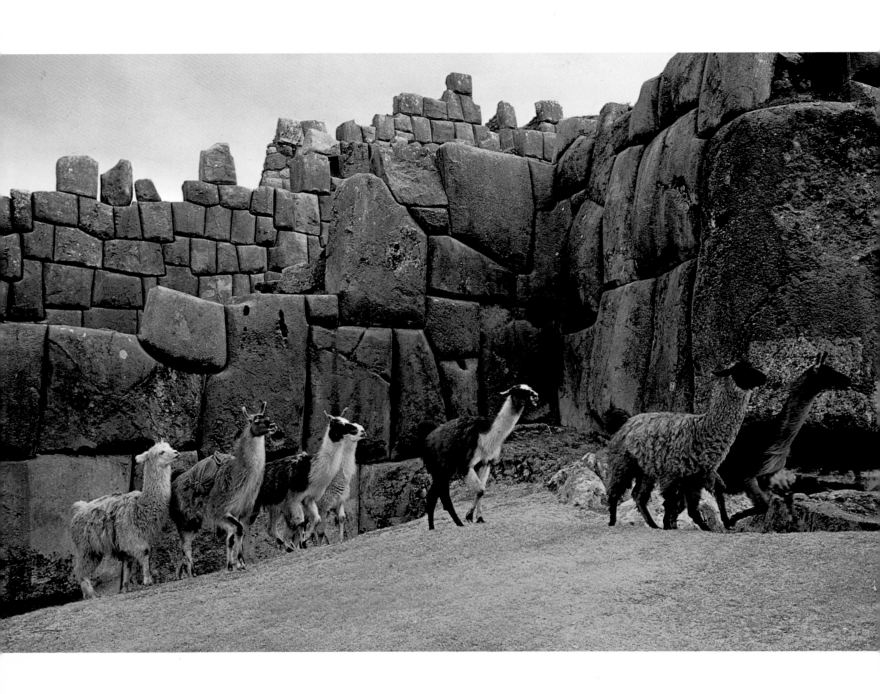

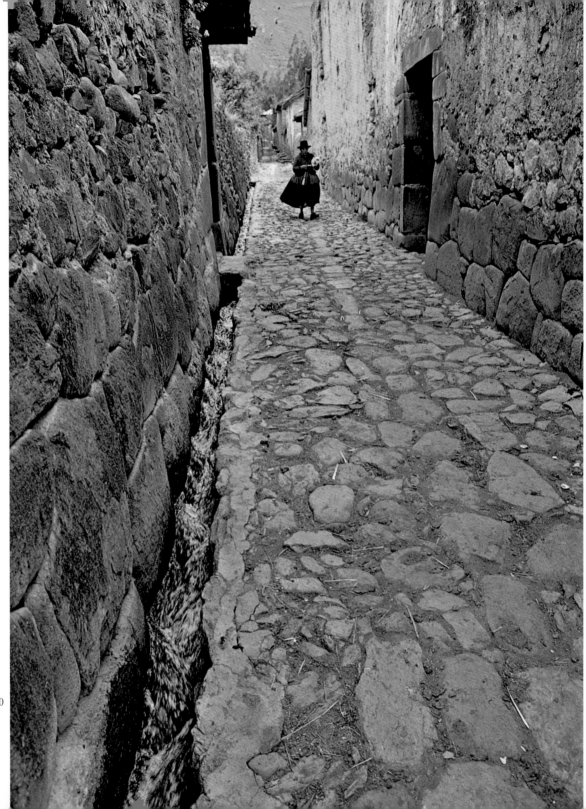

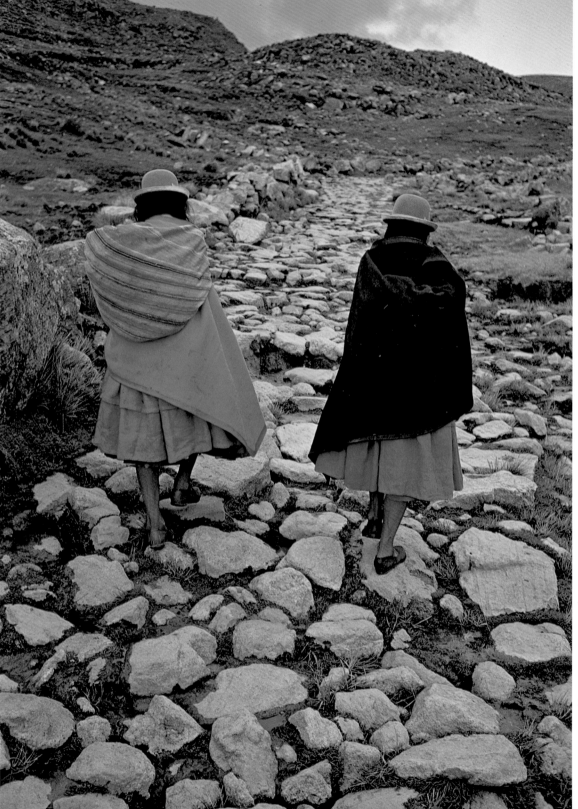

21

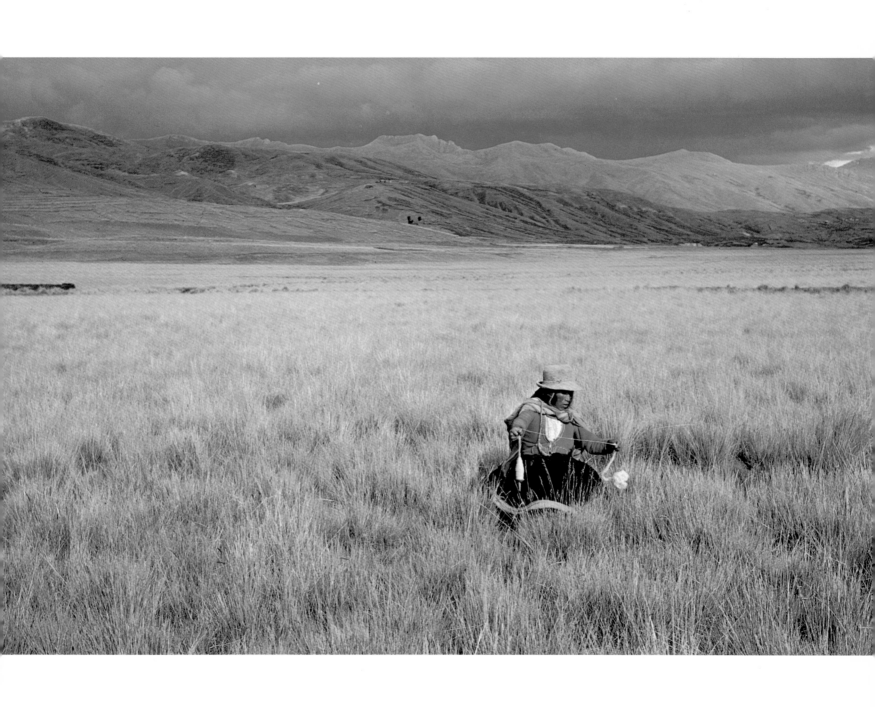

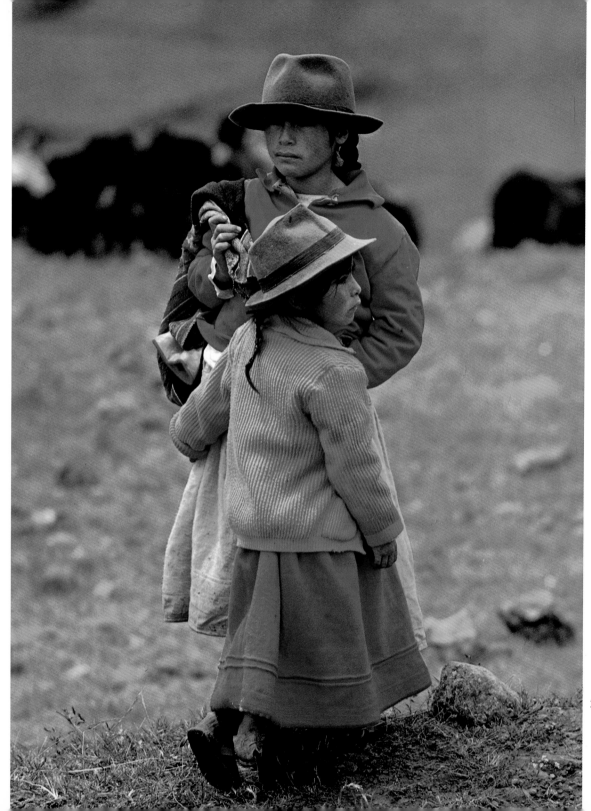

23

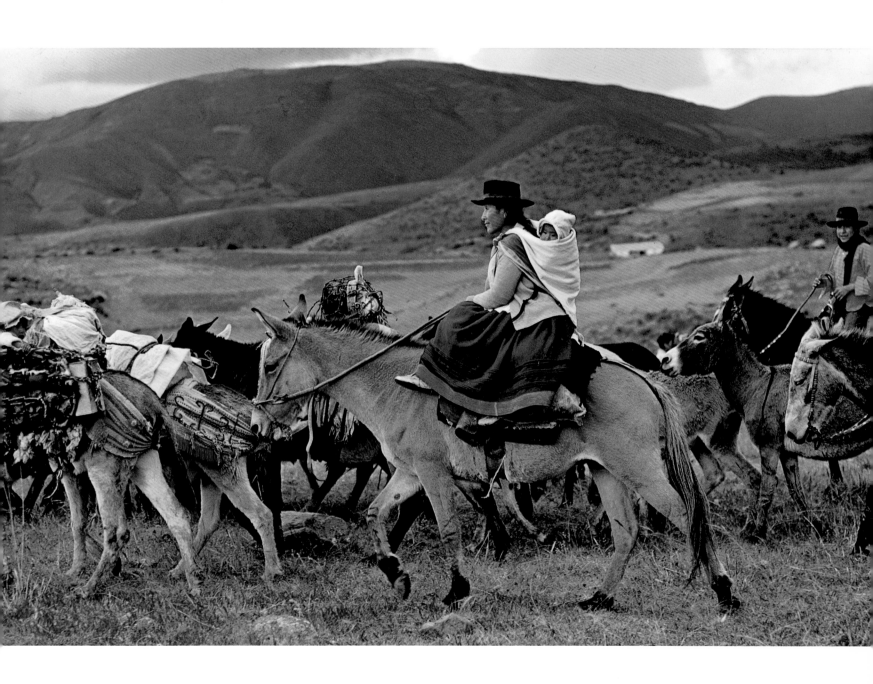

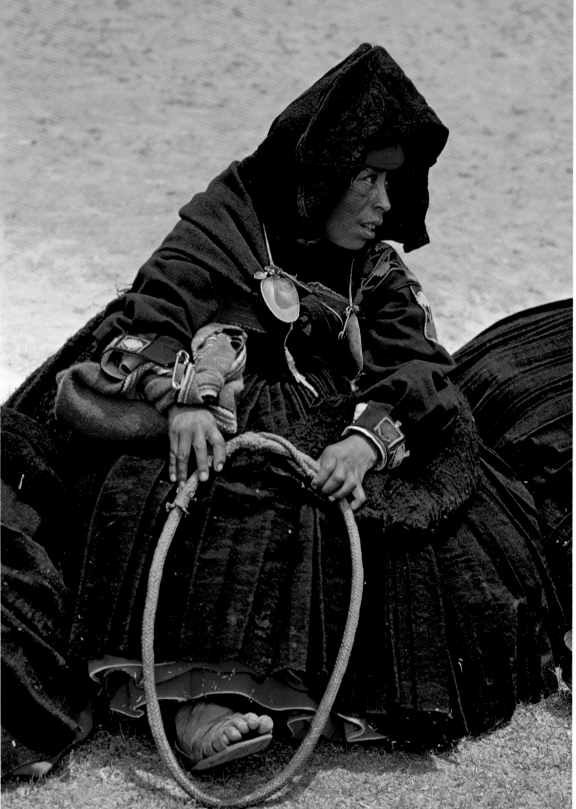

25

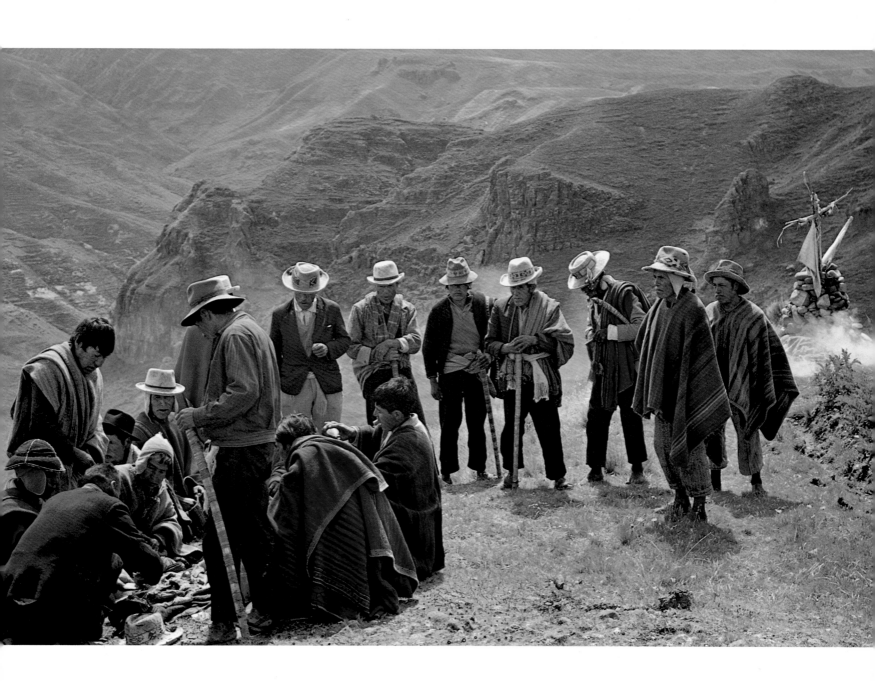

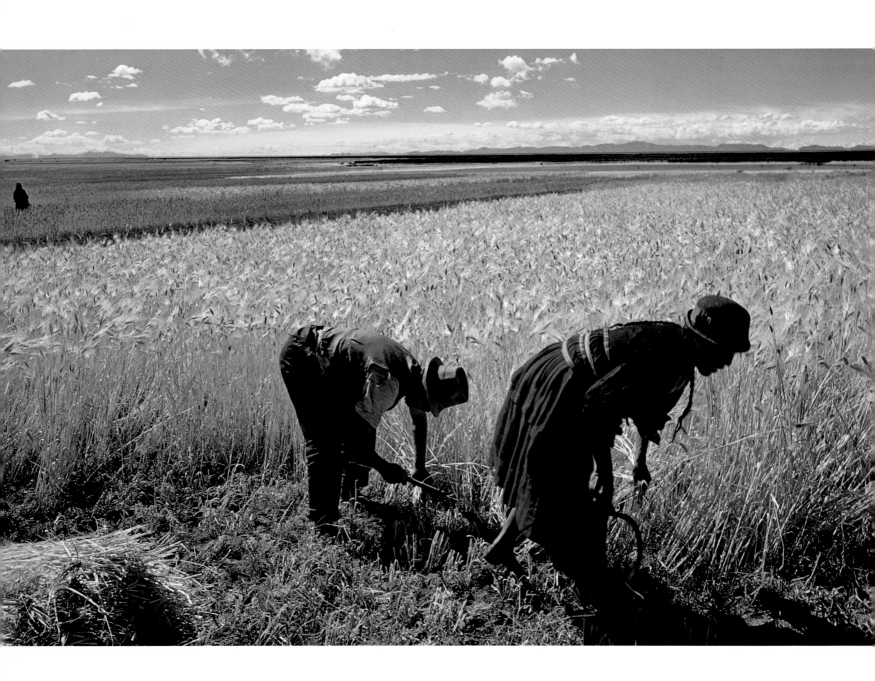

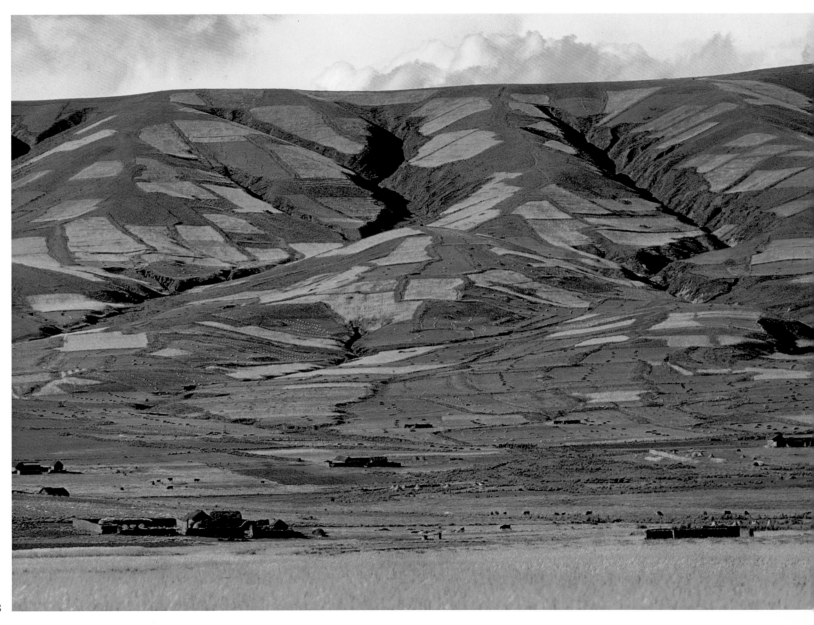

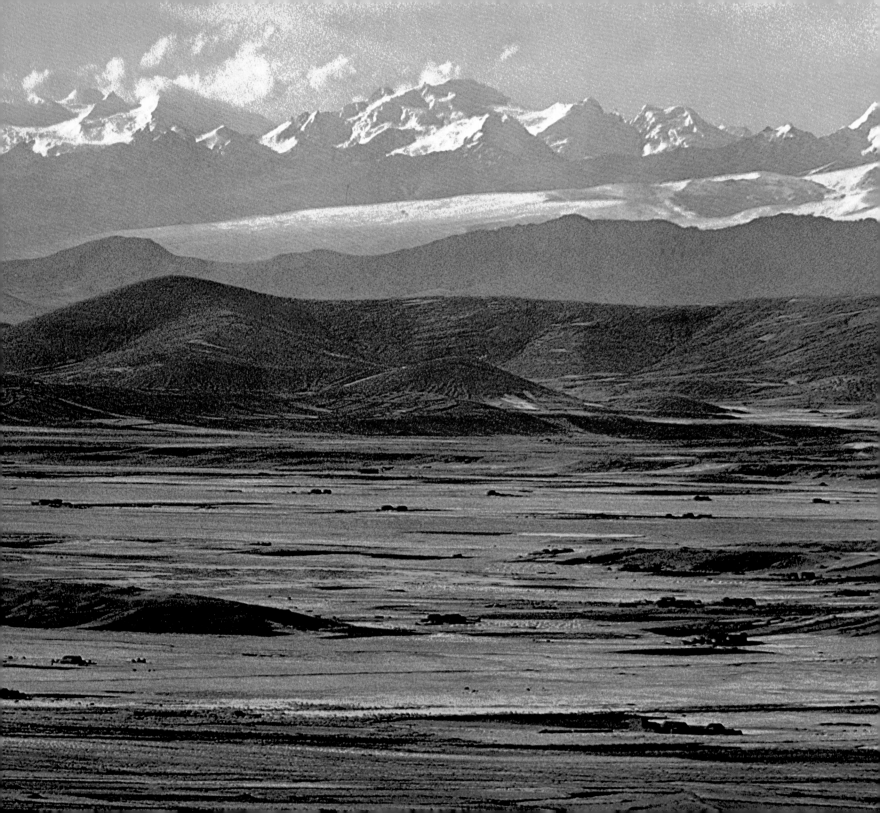

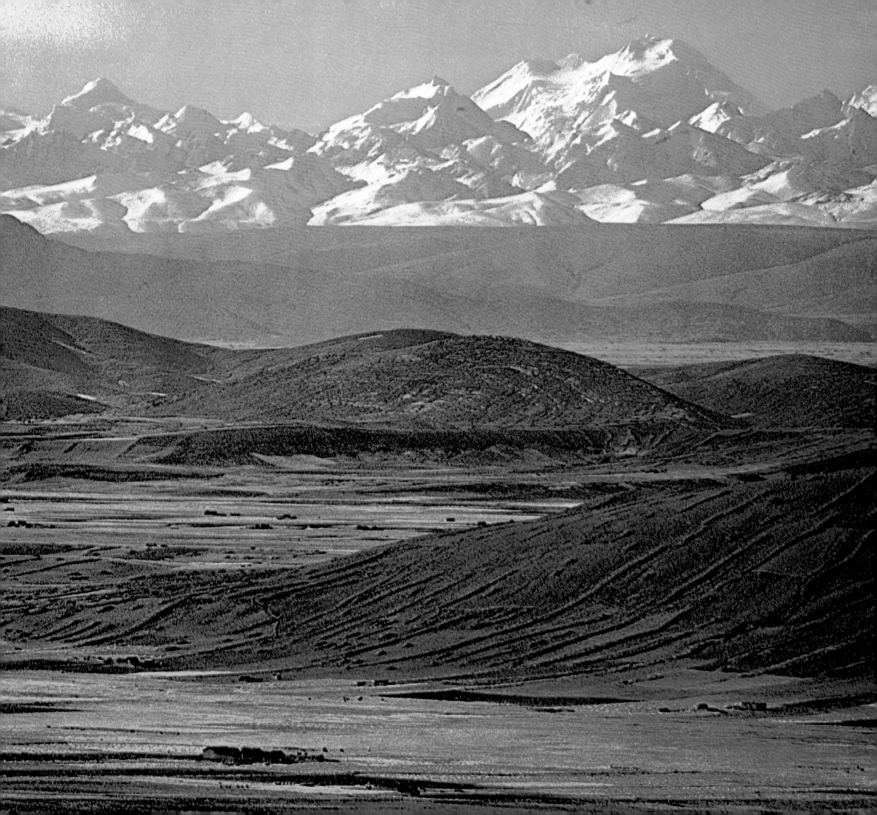

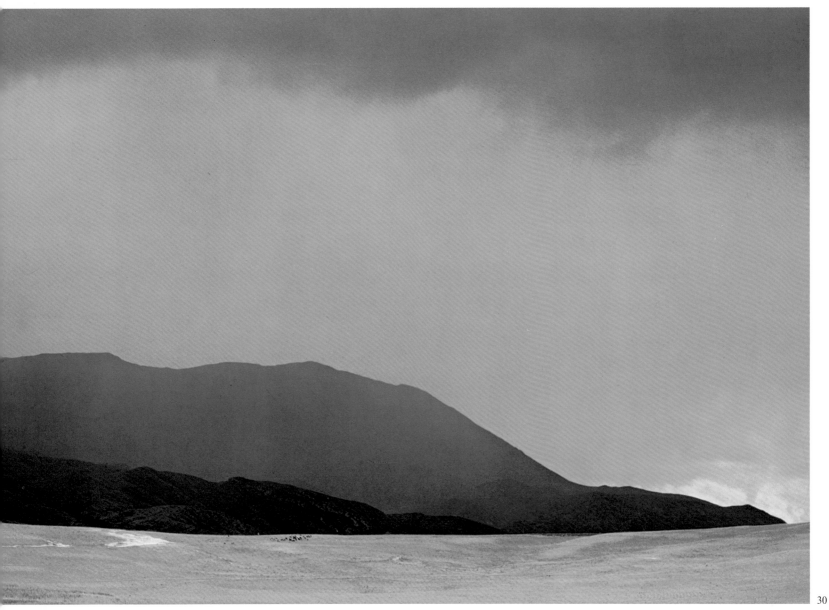

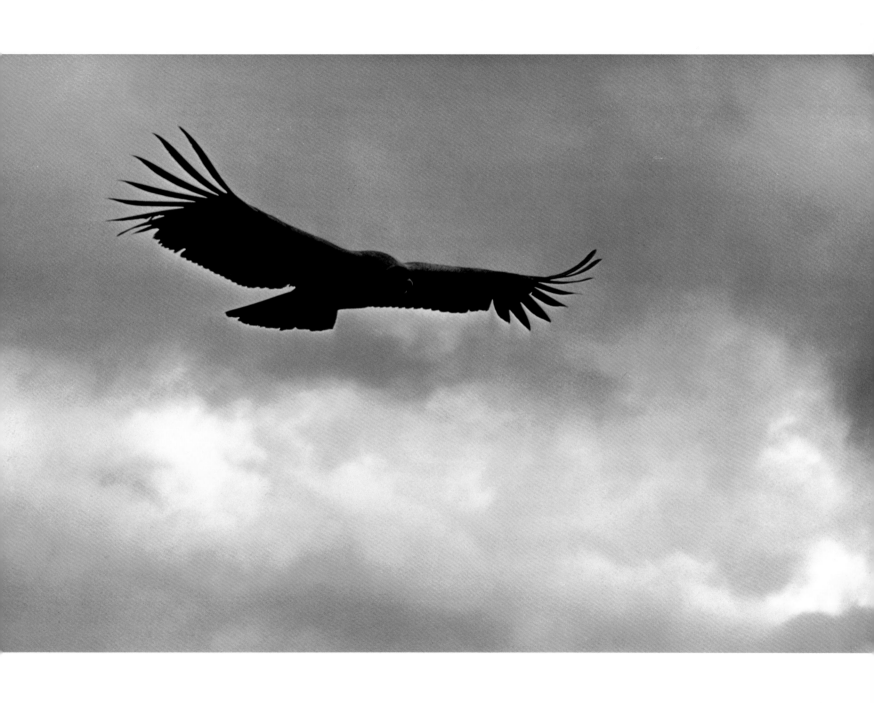

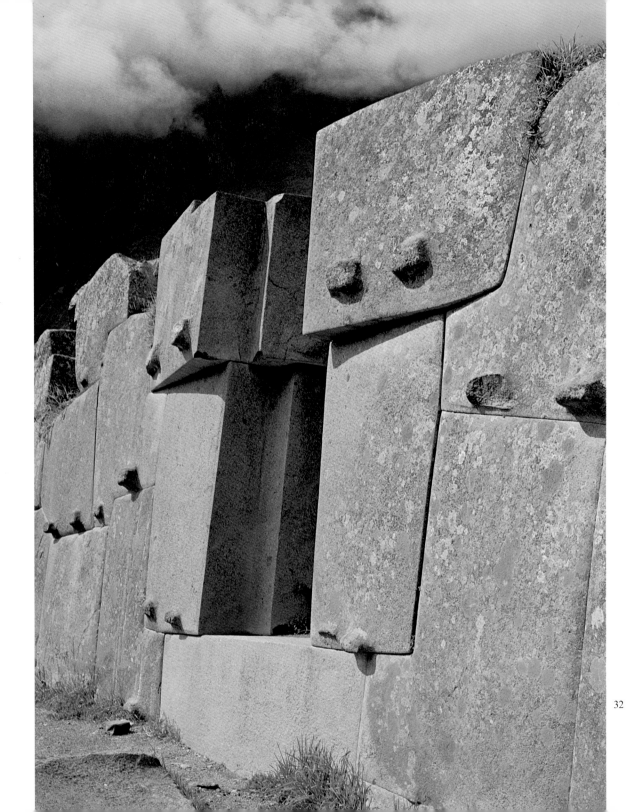

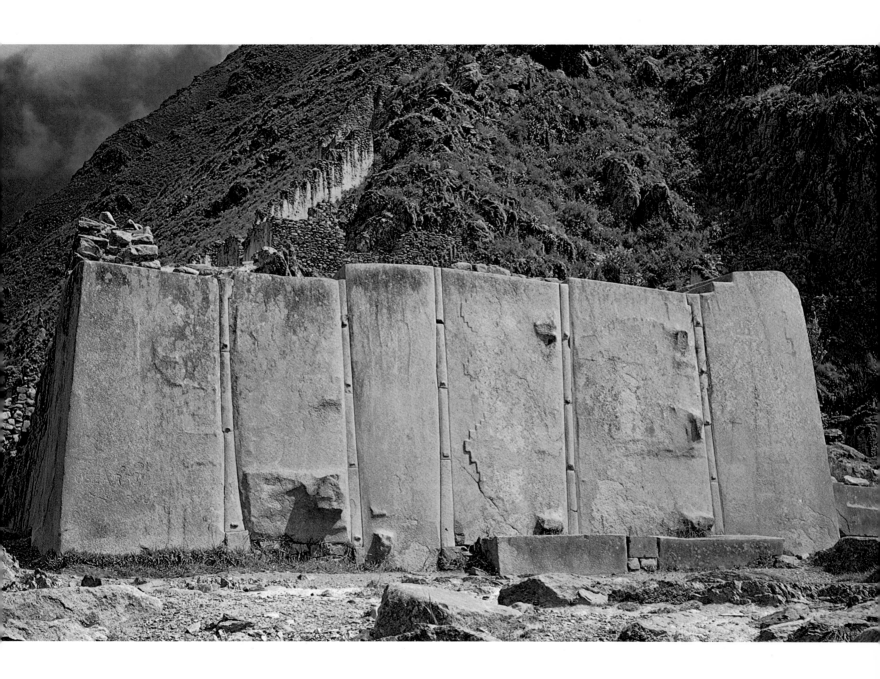

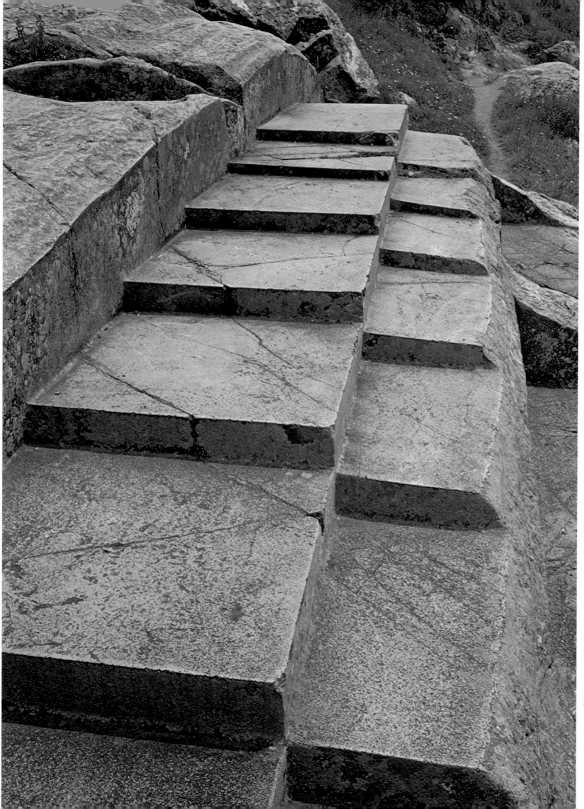

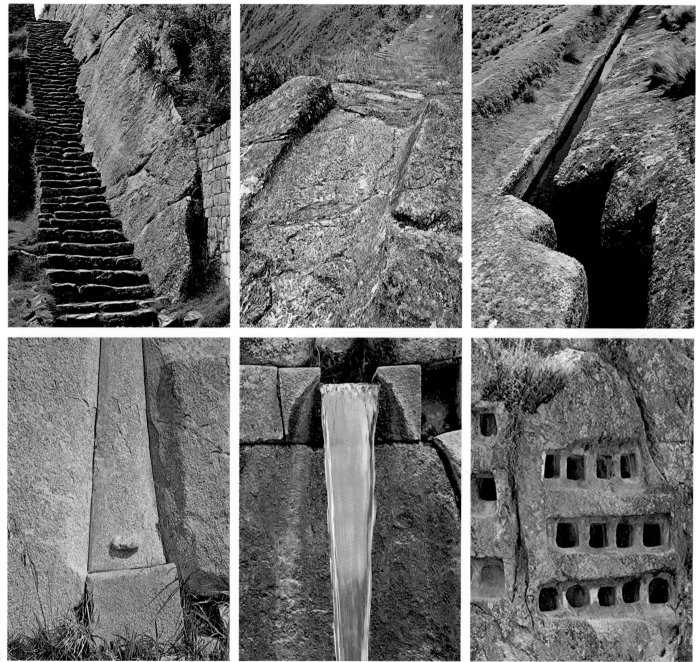

35

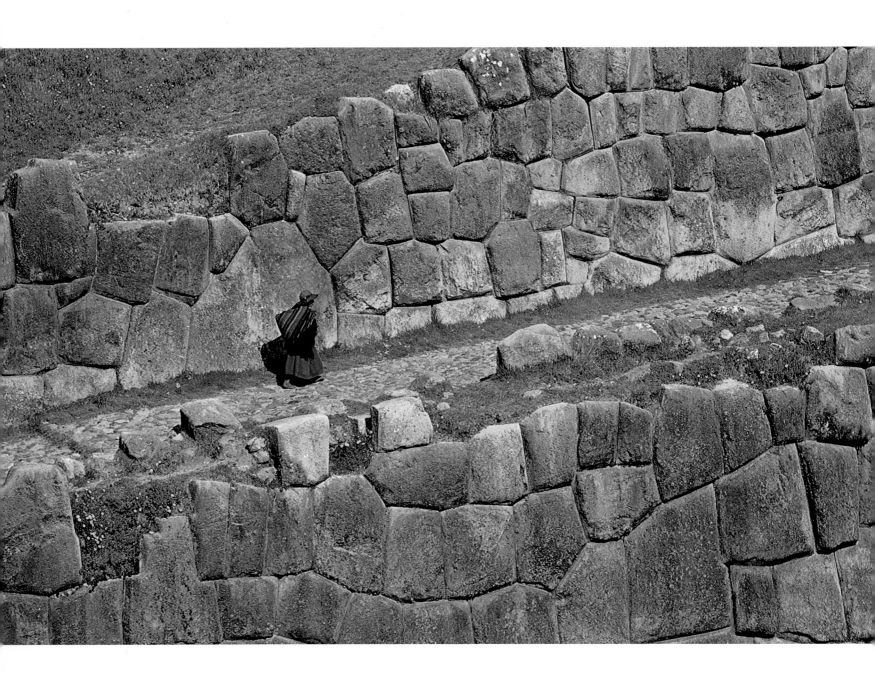

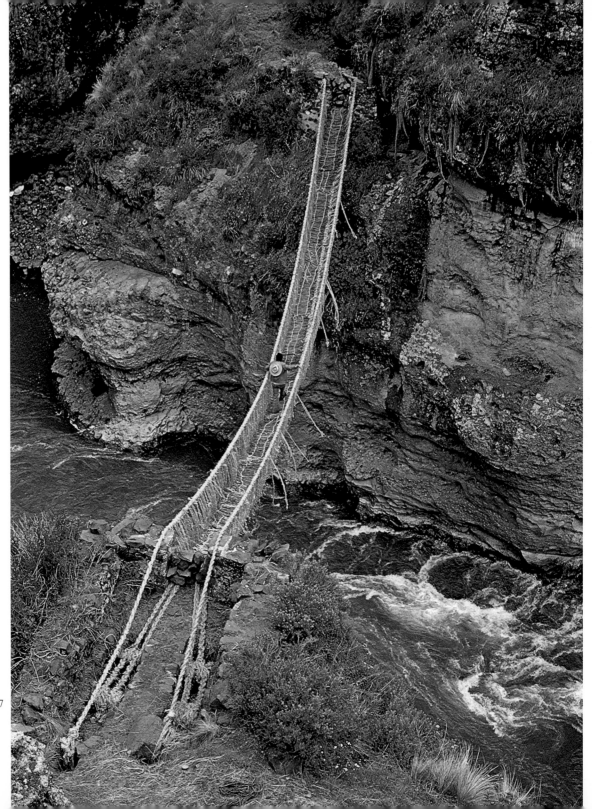

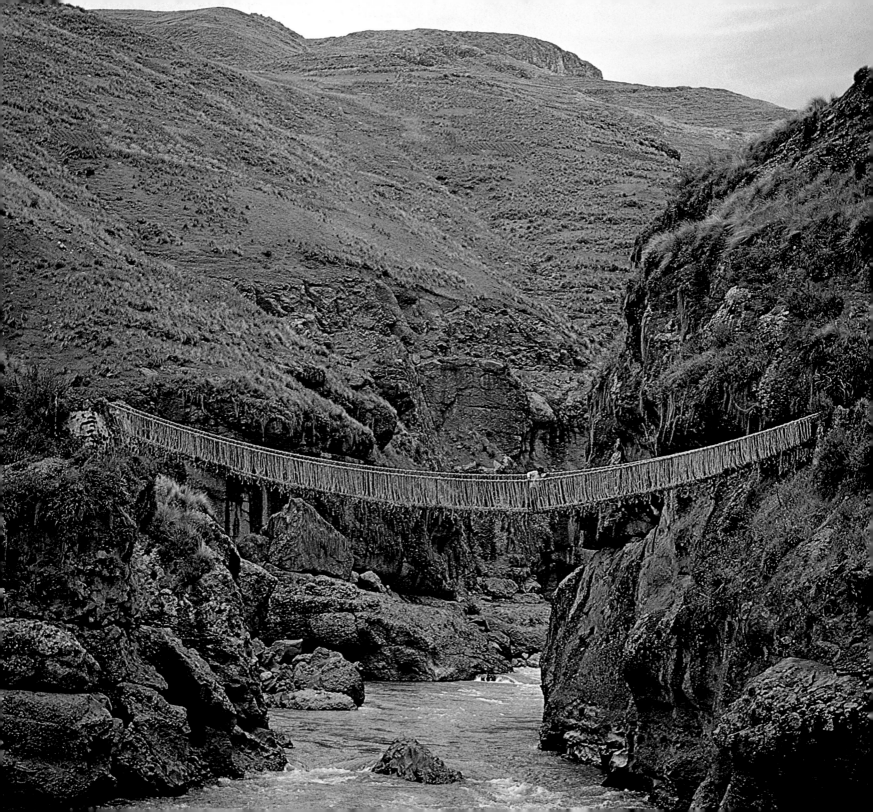

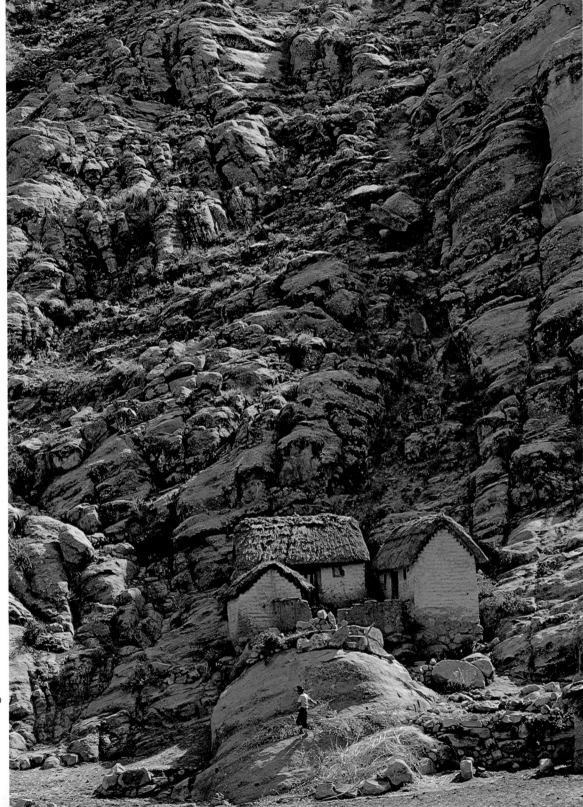

39

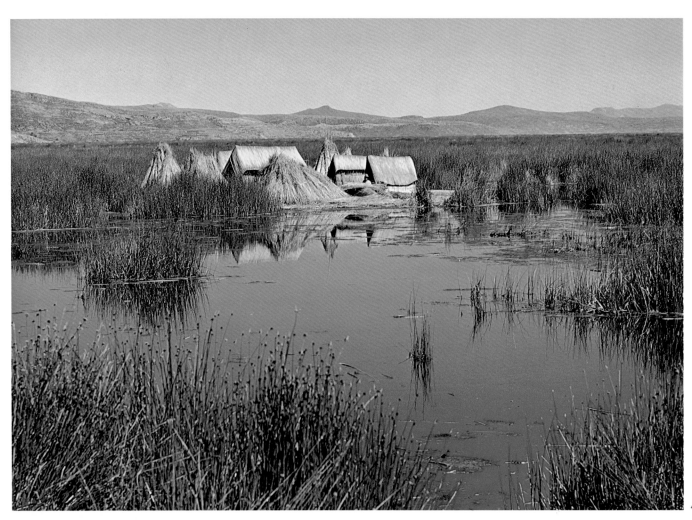

40

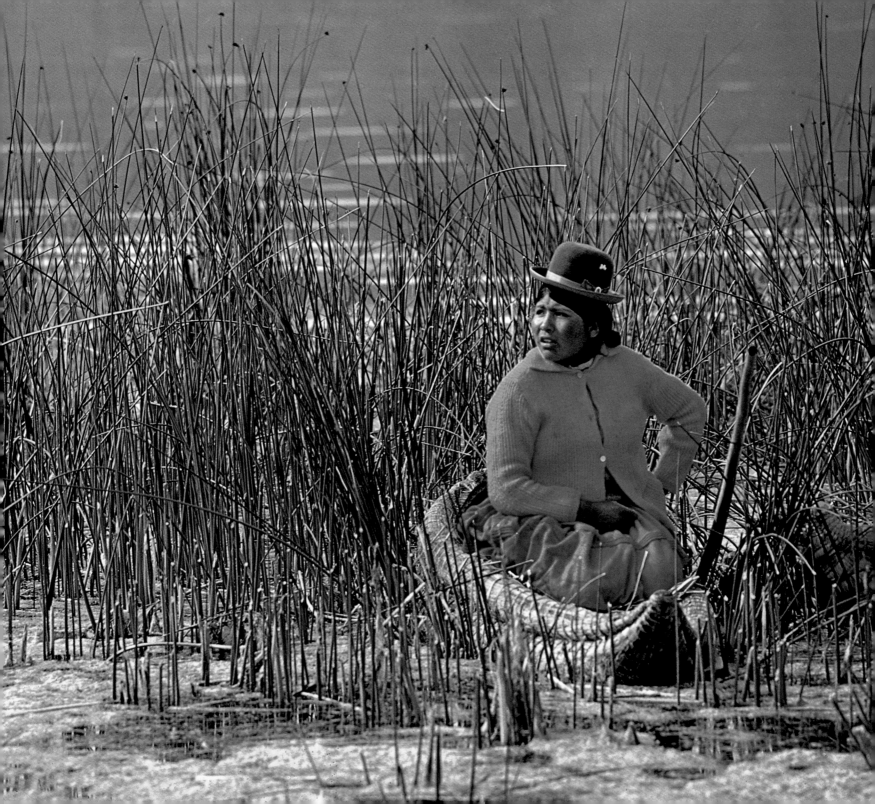

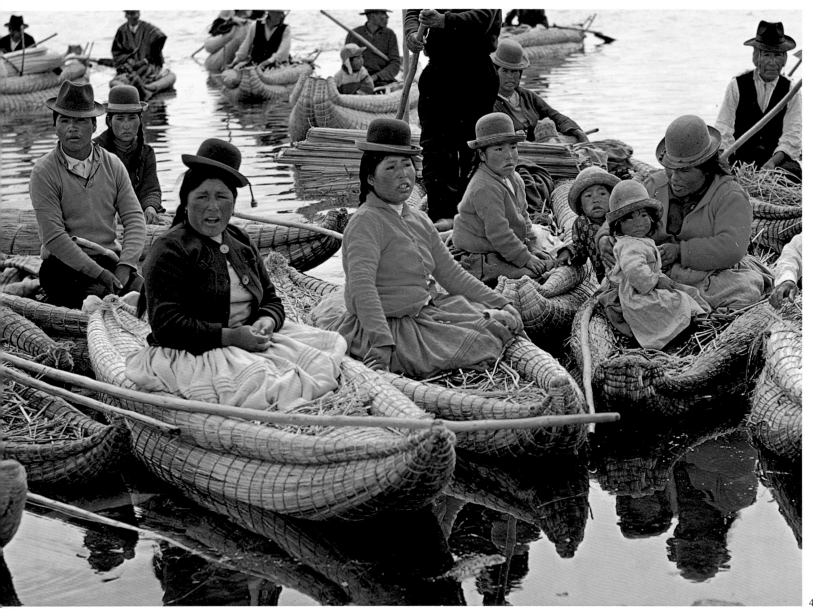

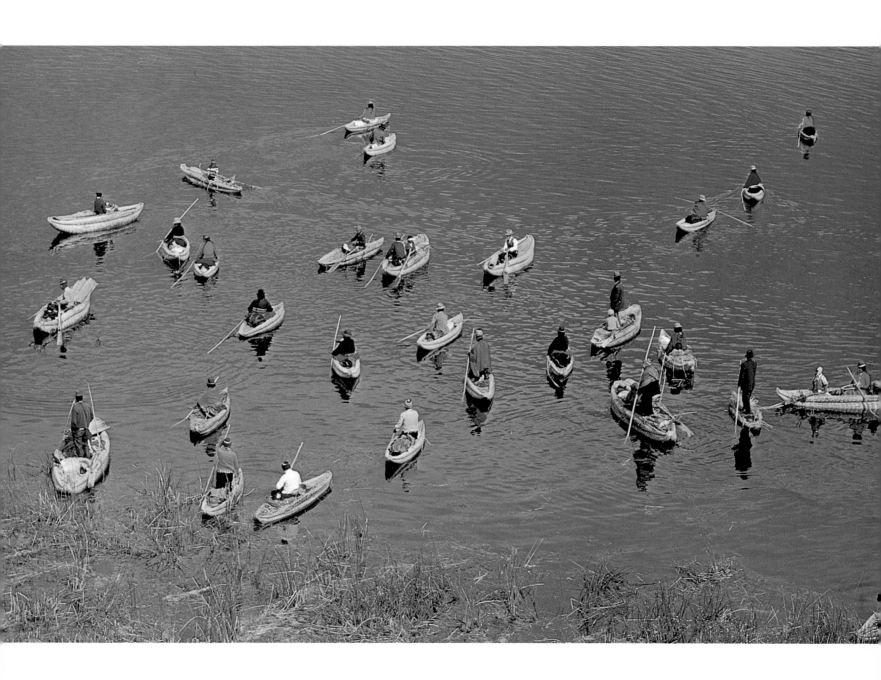

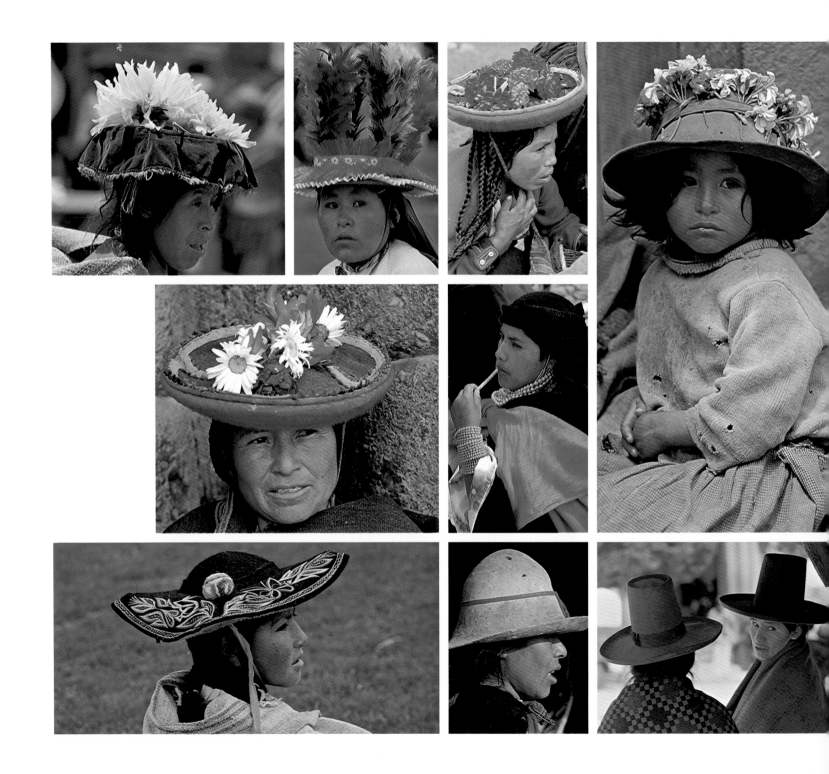

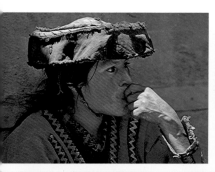
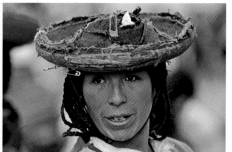
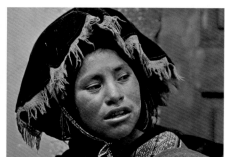
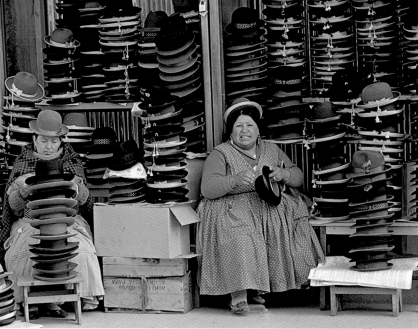
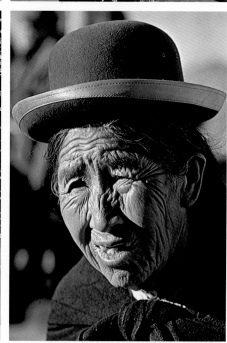
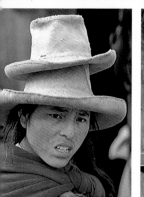
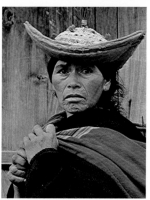
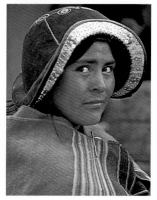
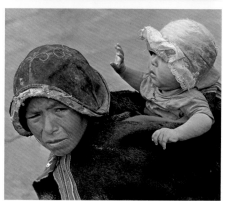

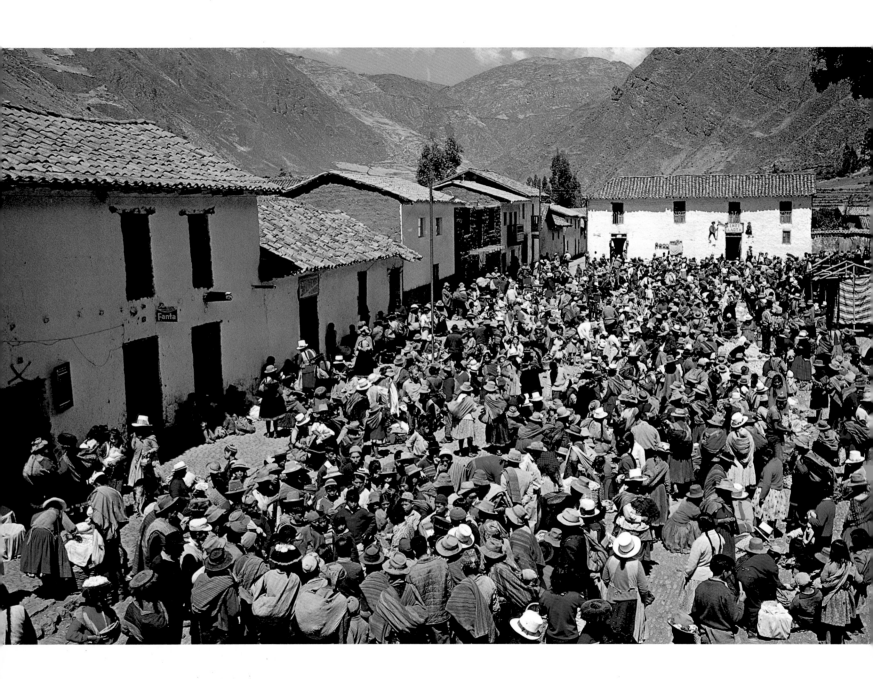

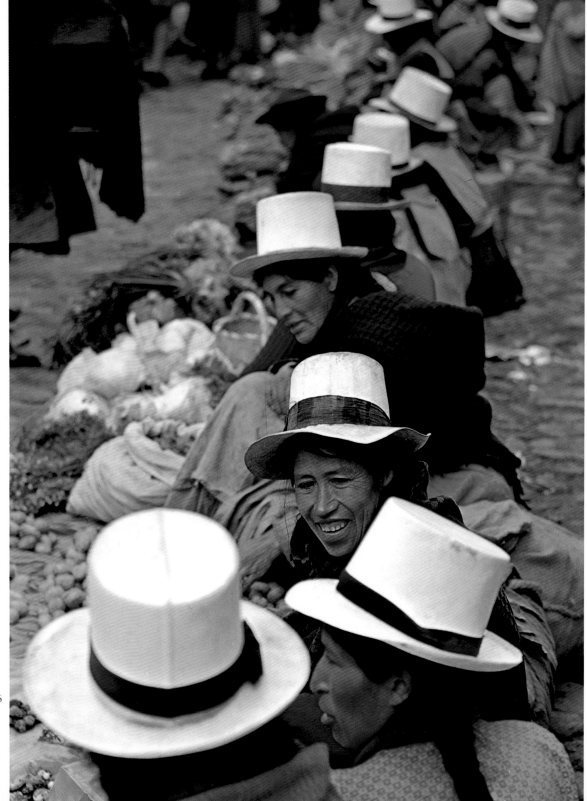

46

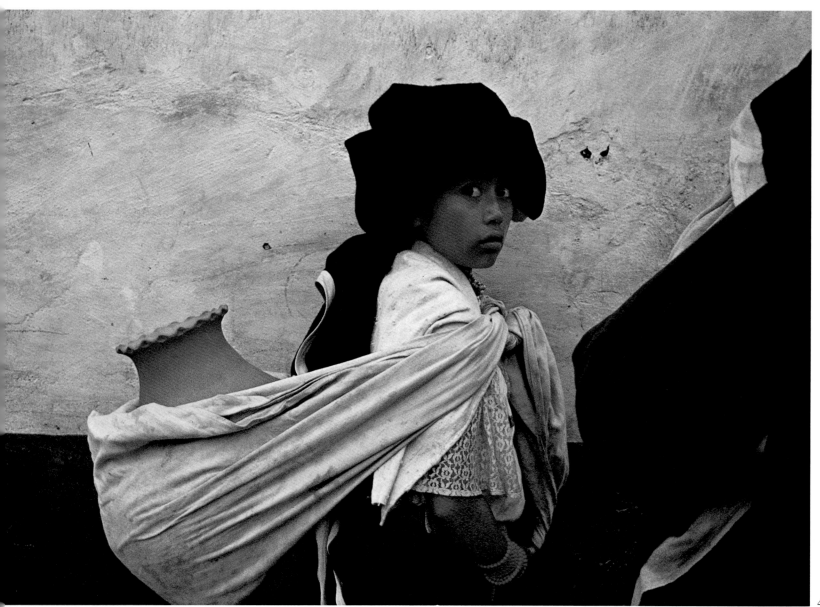

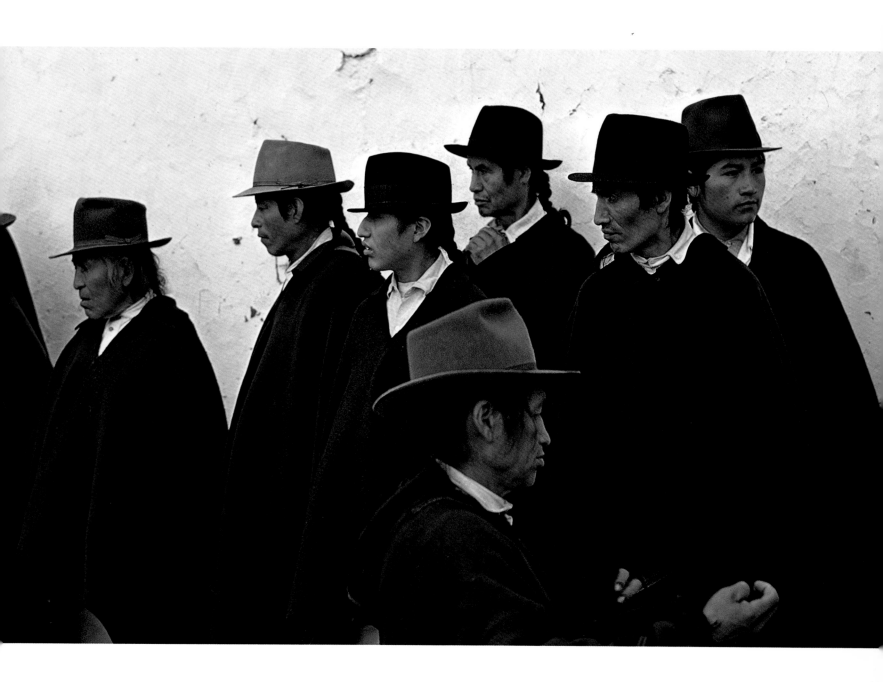

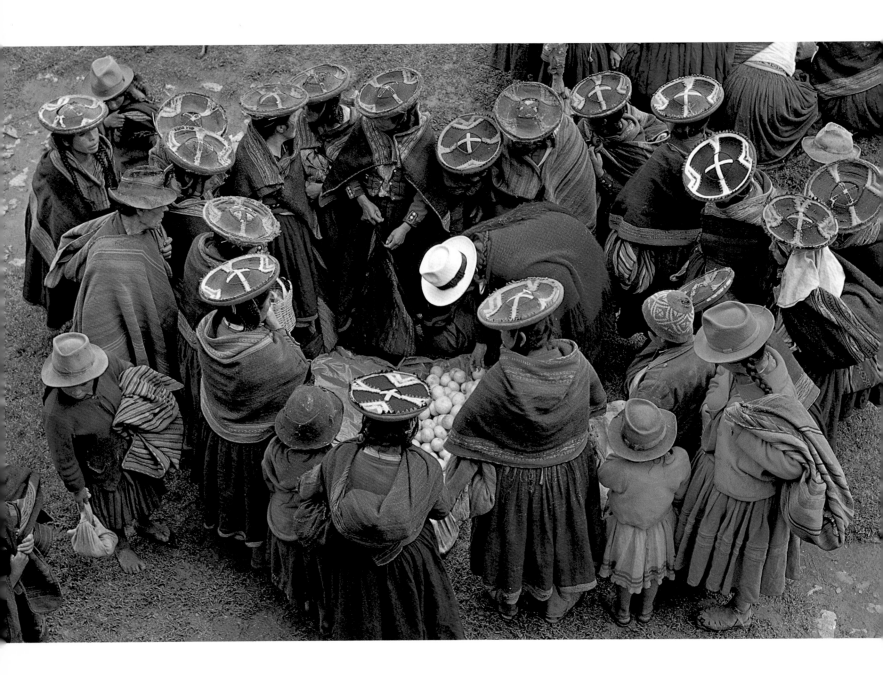

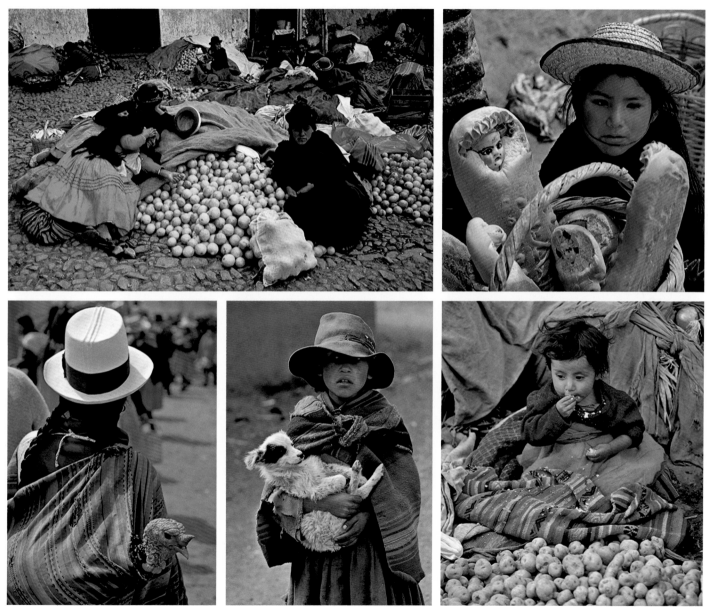

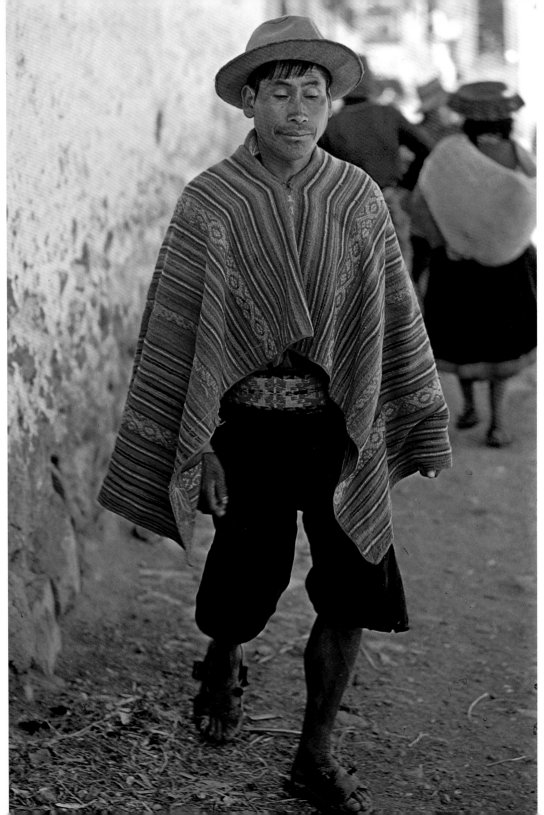

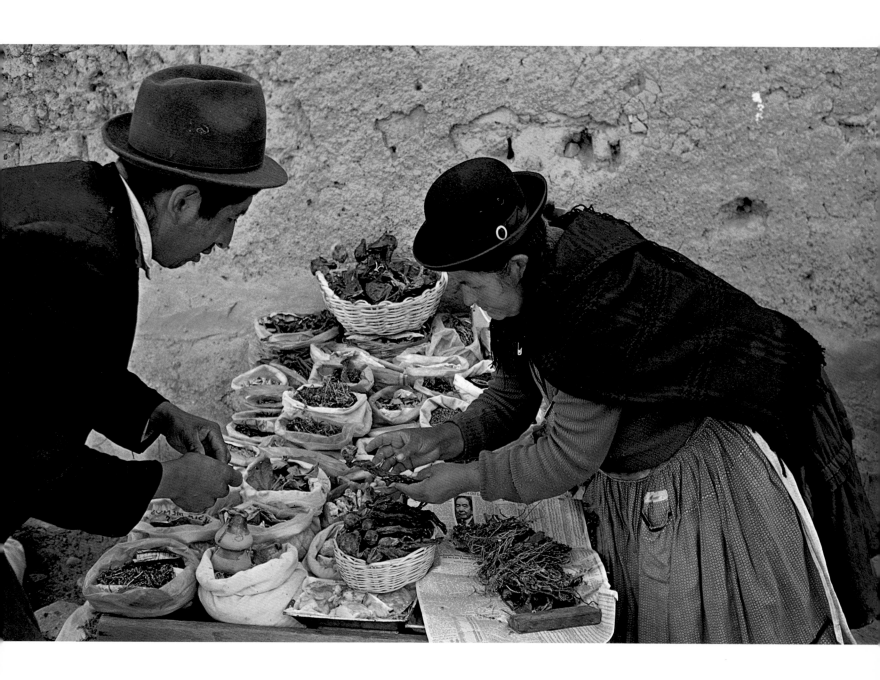

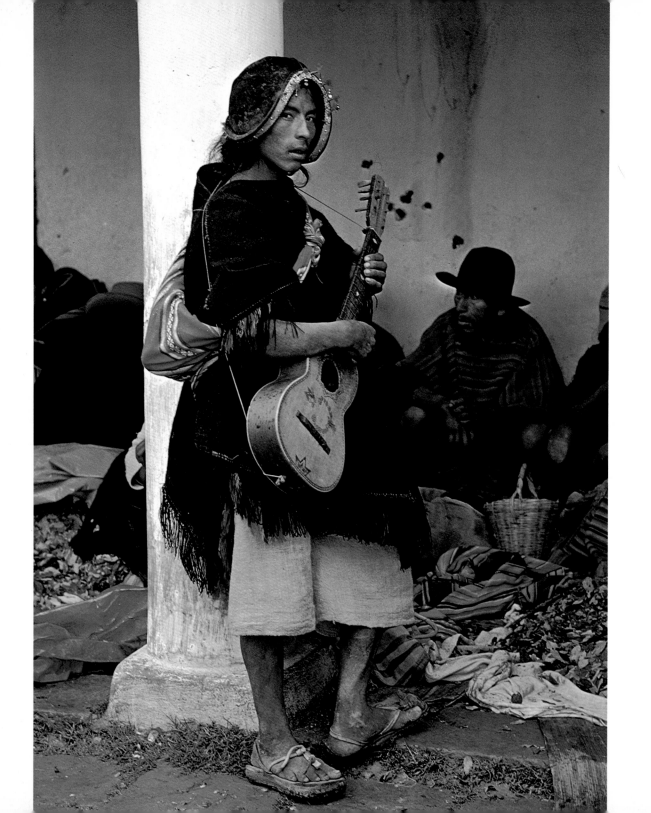

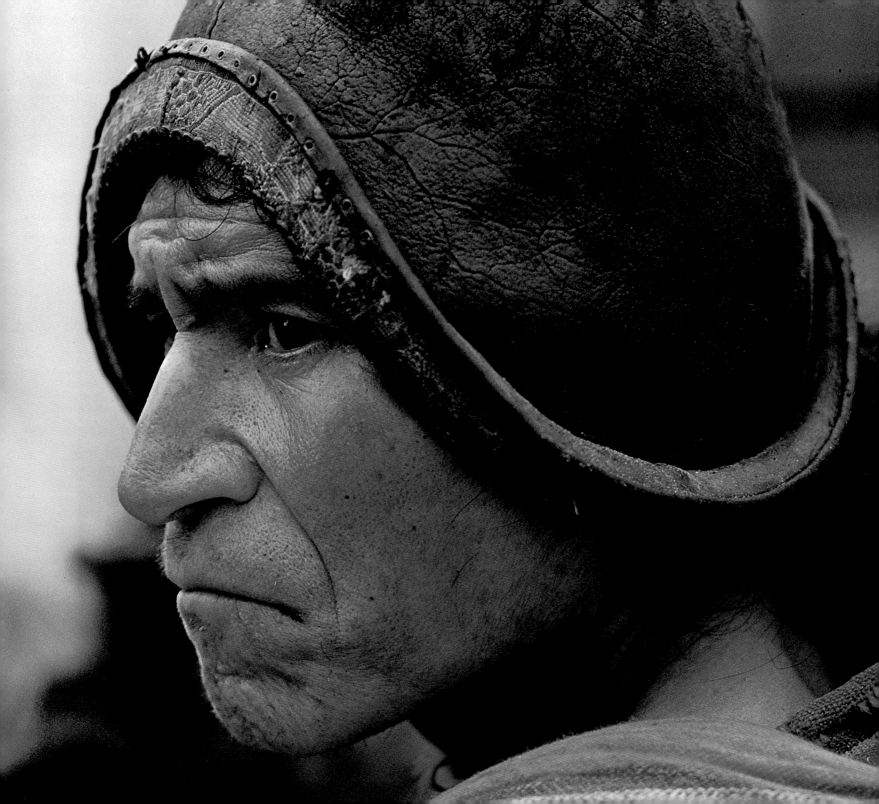

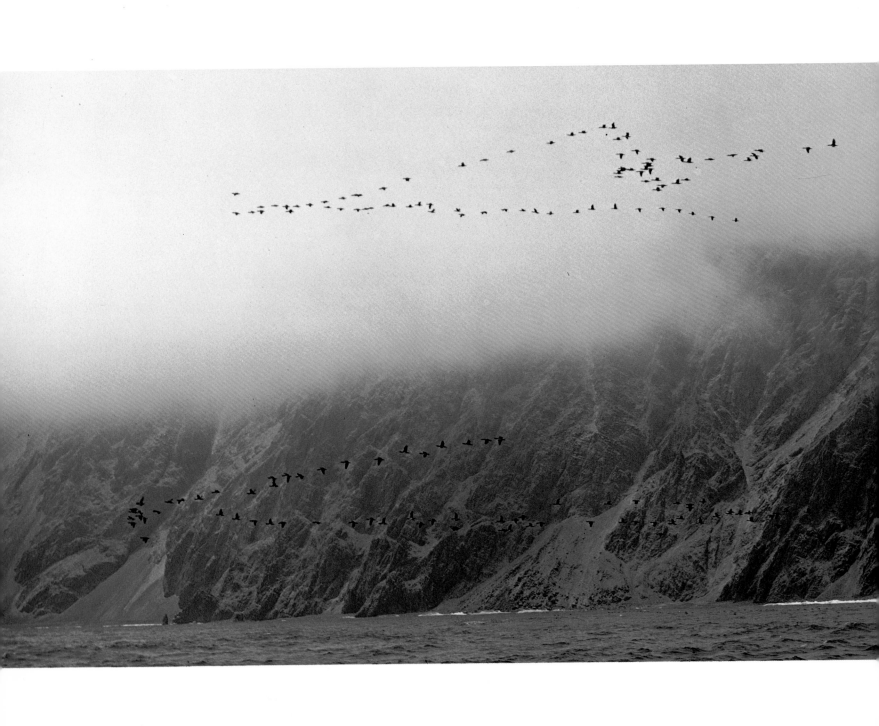

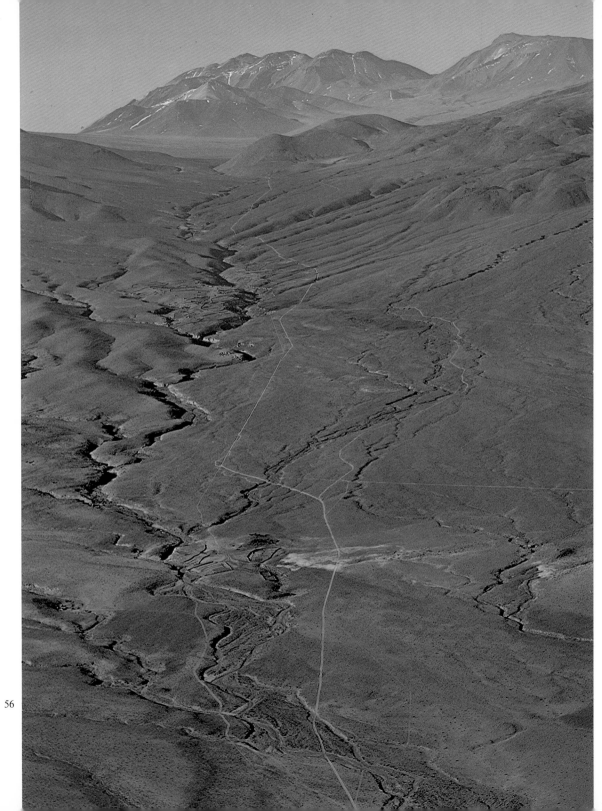

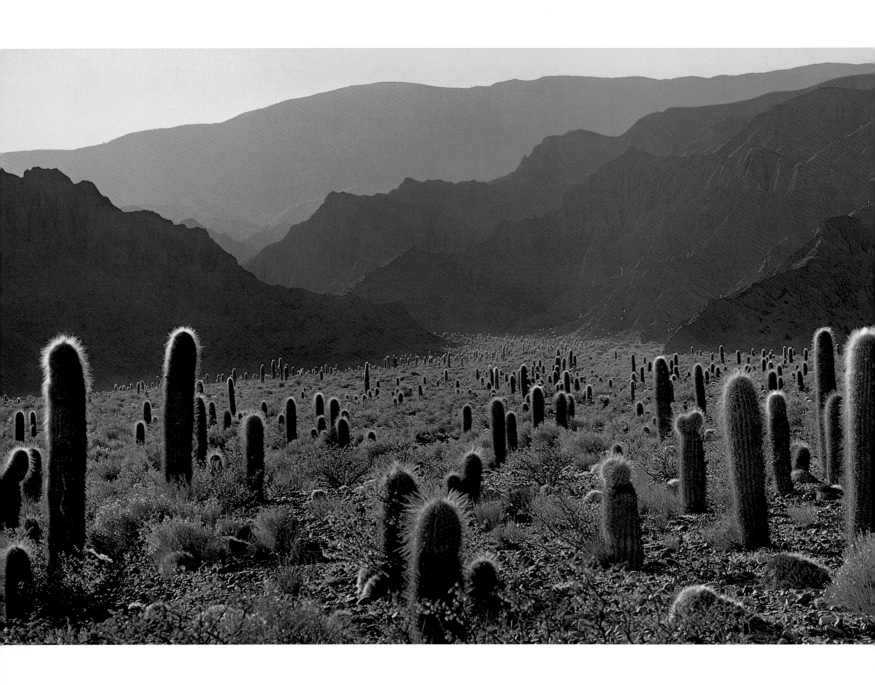

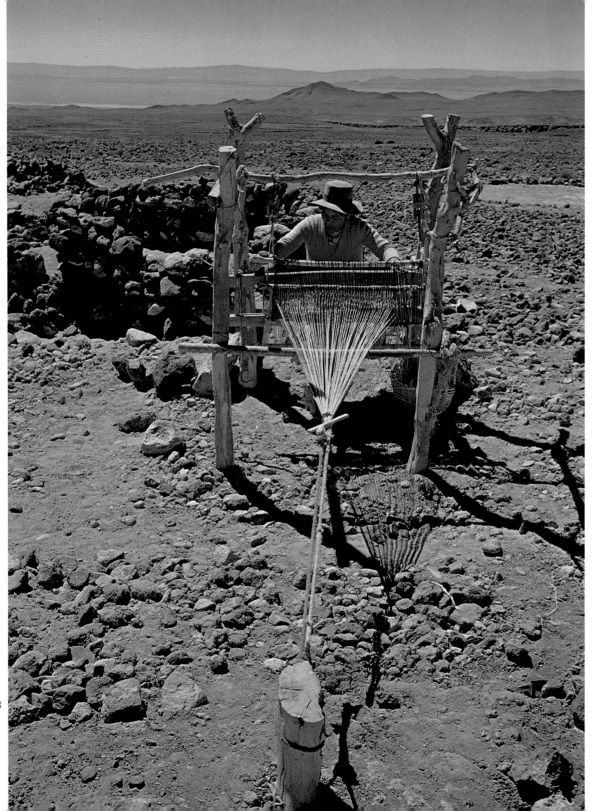

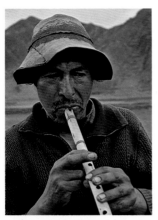
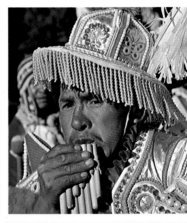
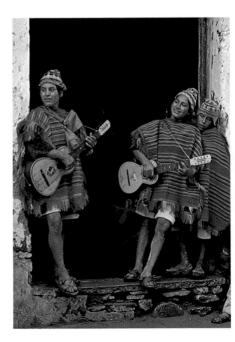
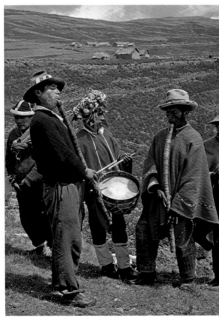
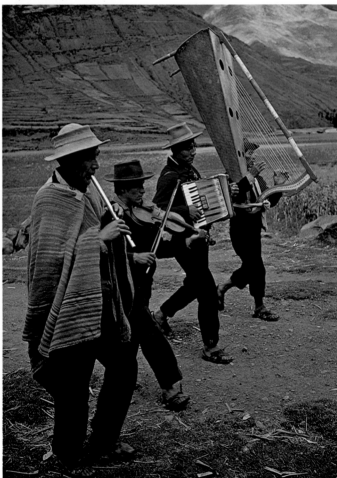

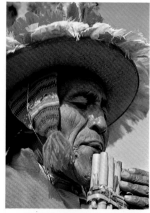
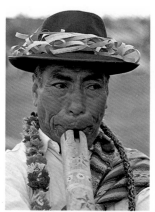
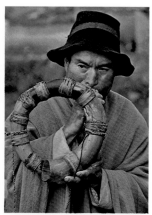
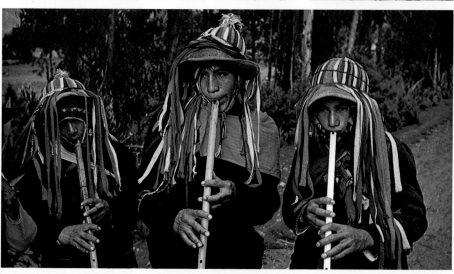
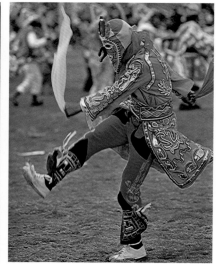
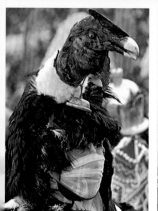
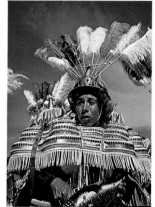
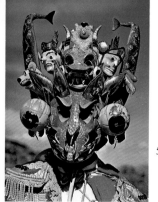

59

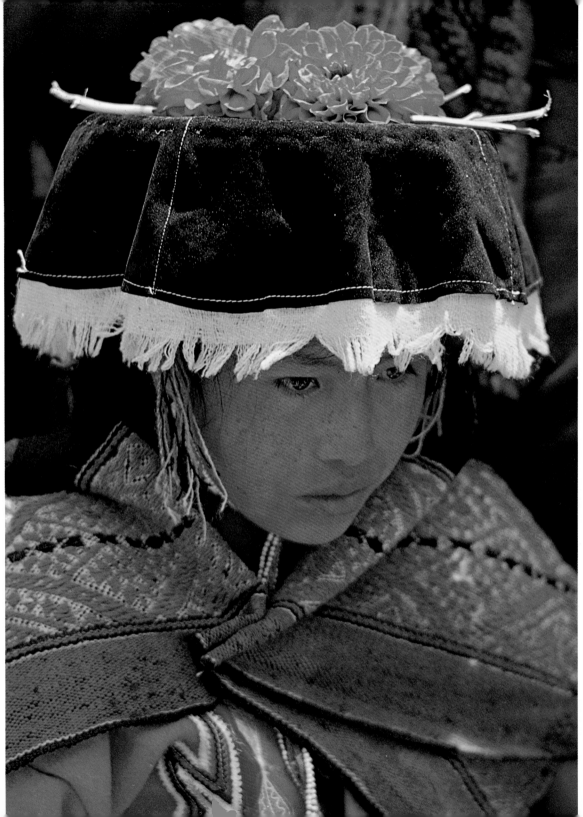

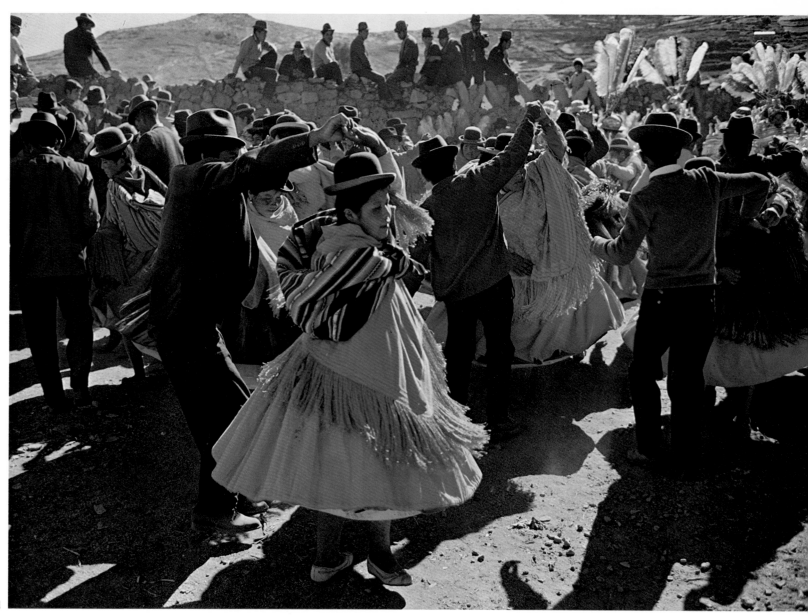

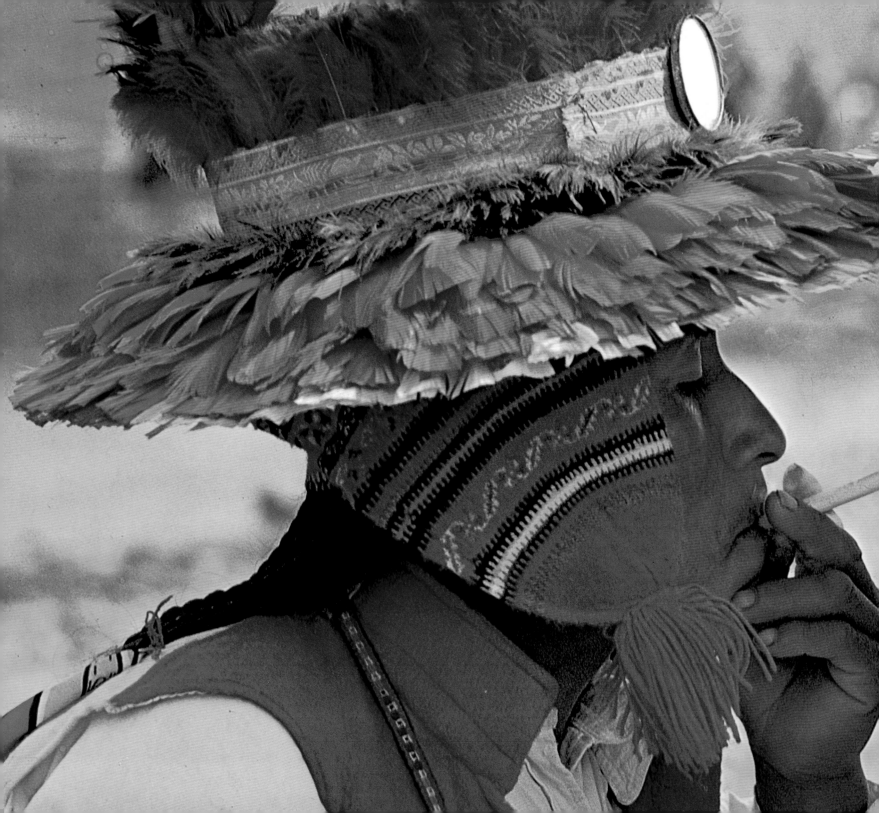

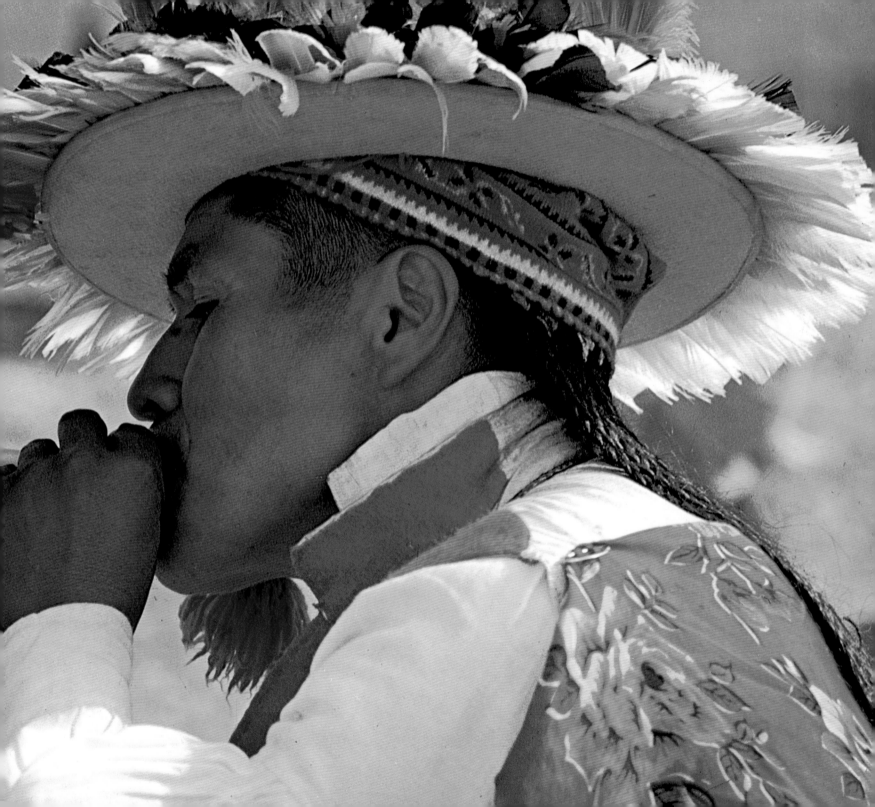

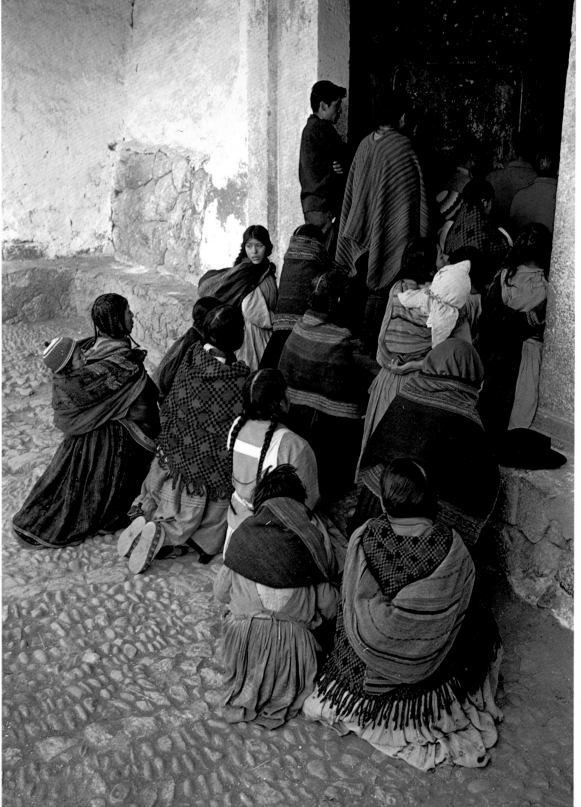

63

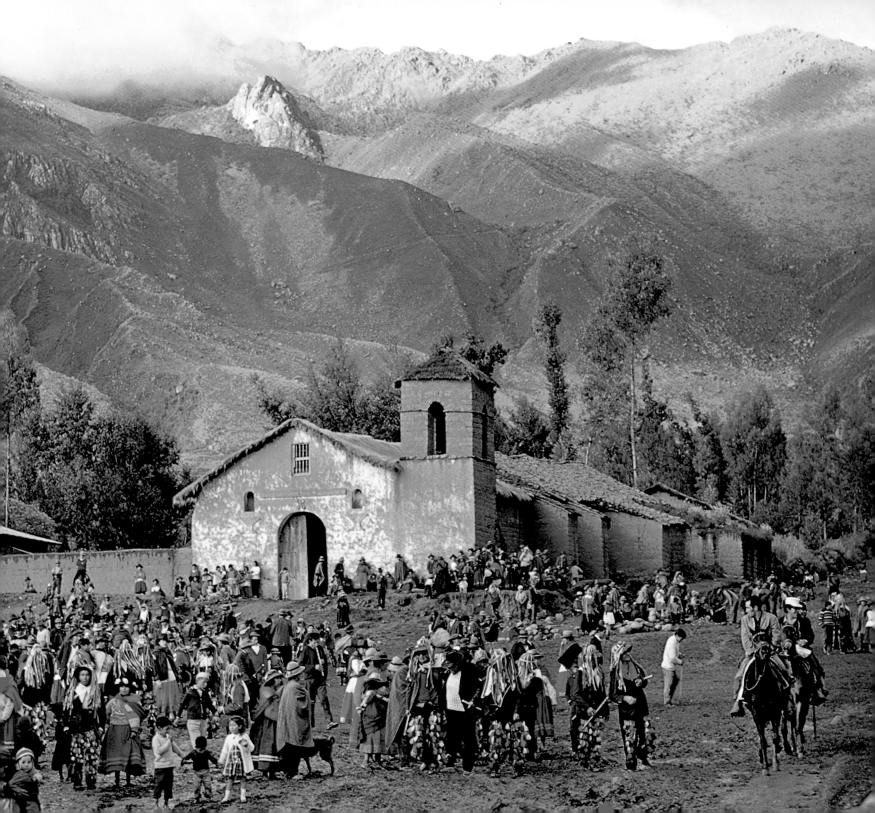

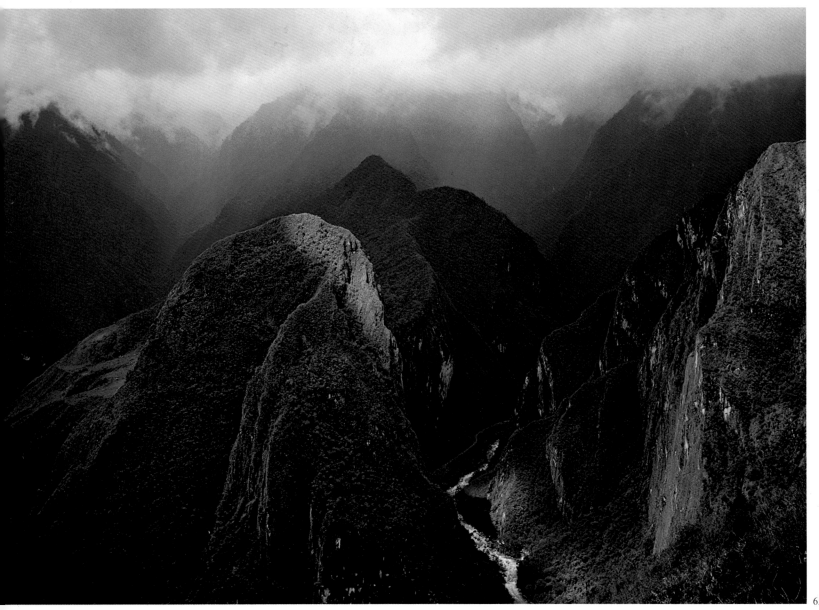

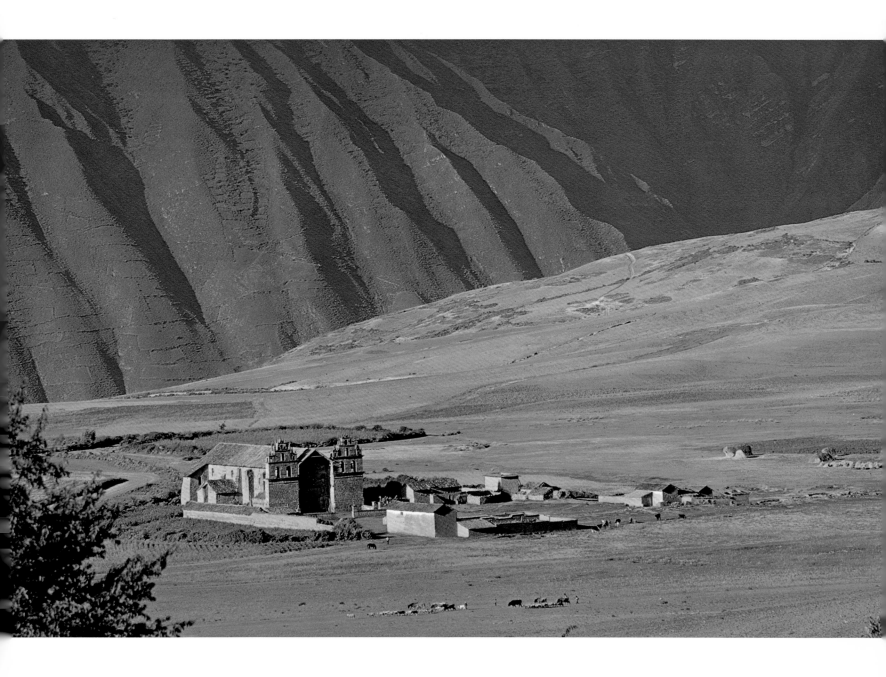

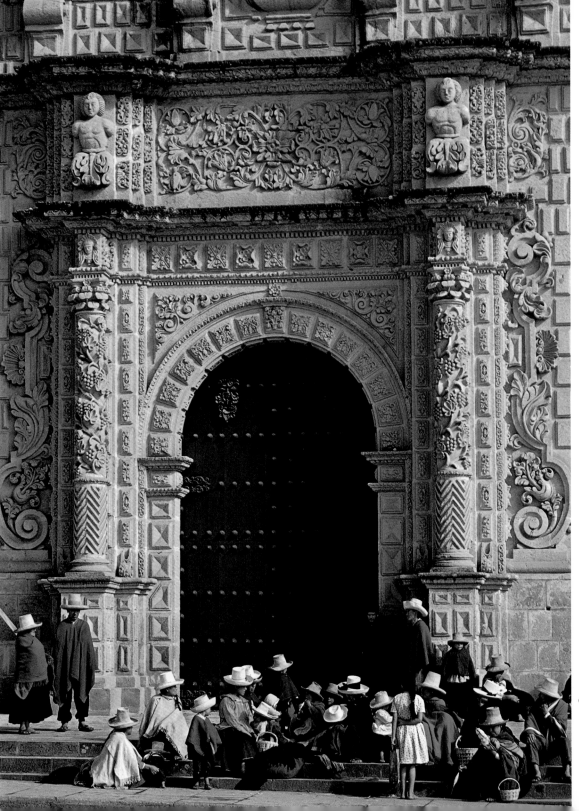

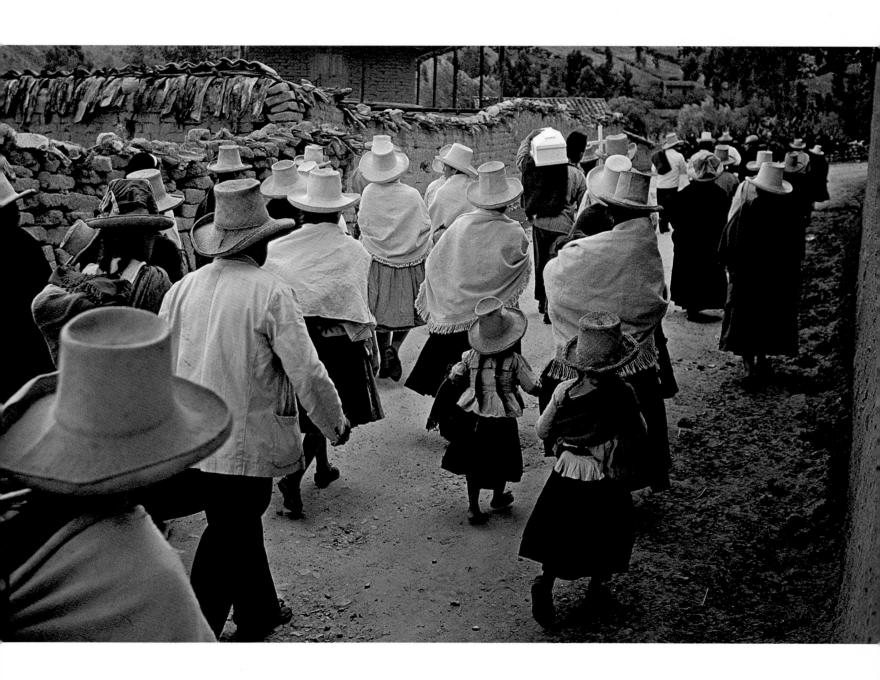

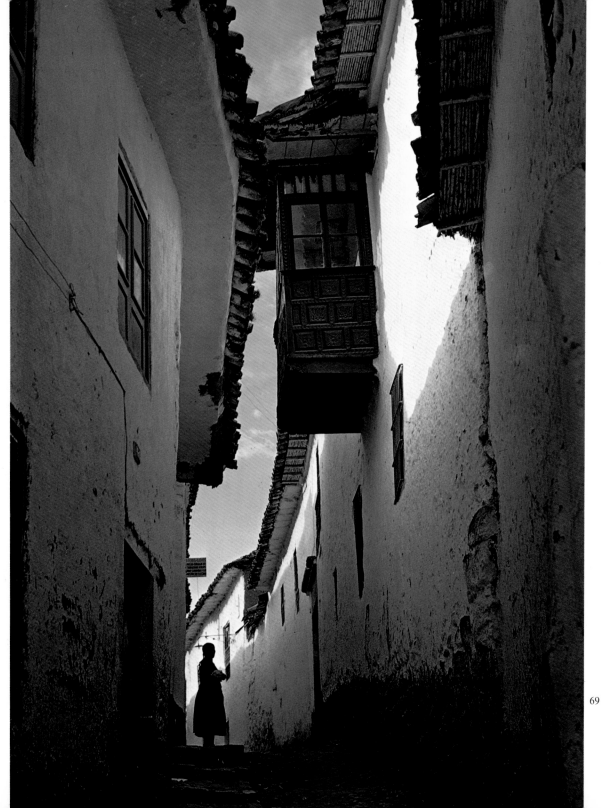

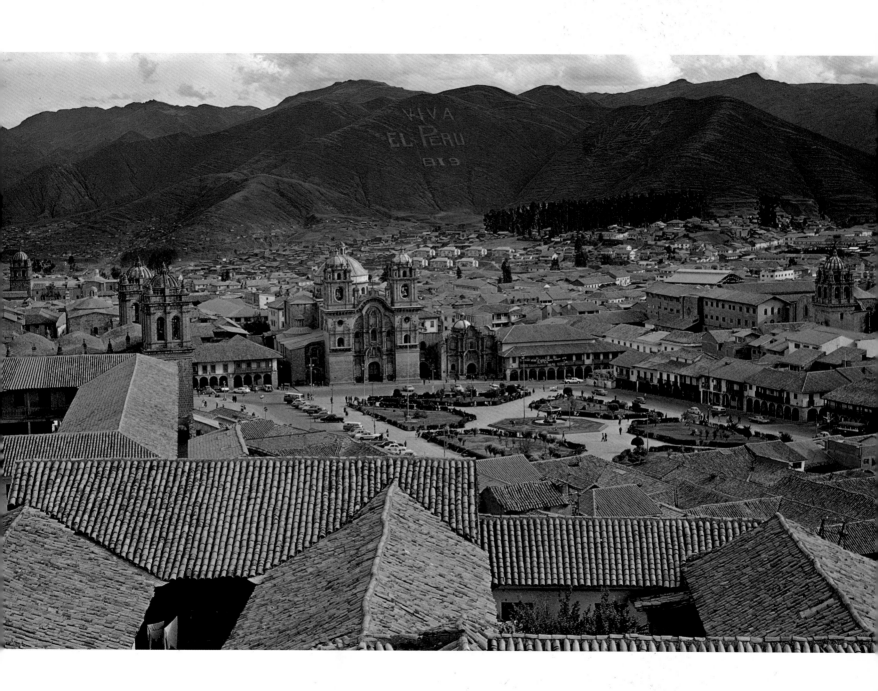

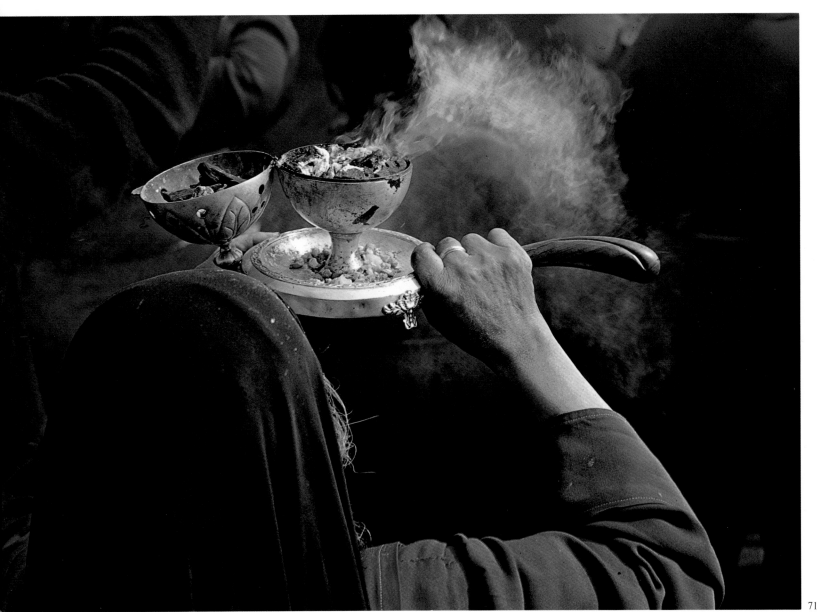

71

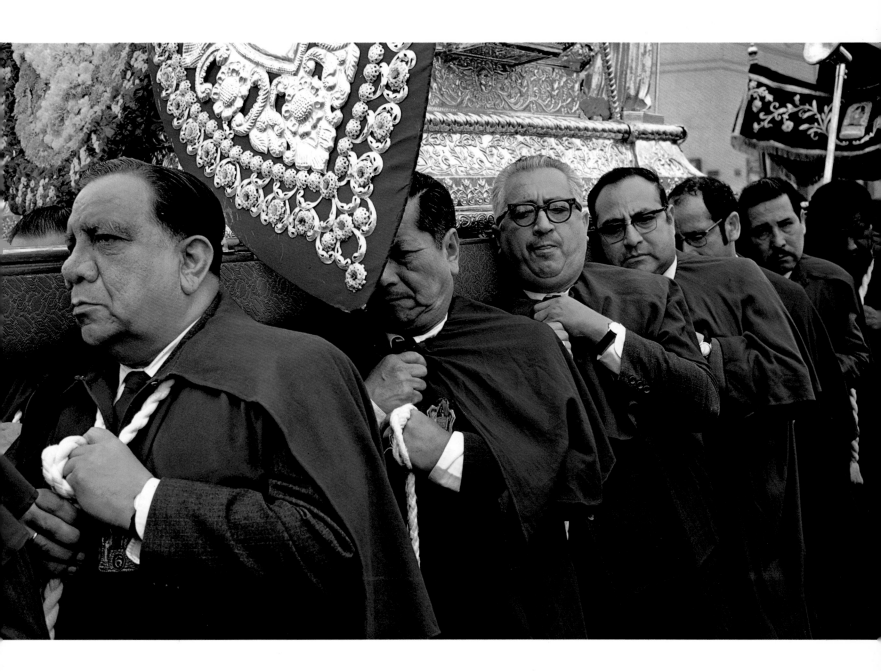

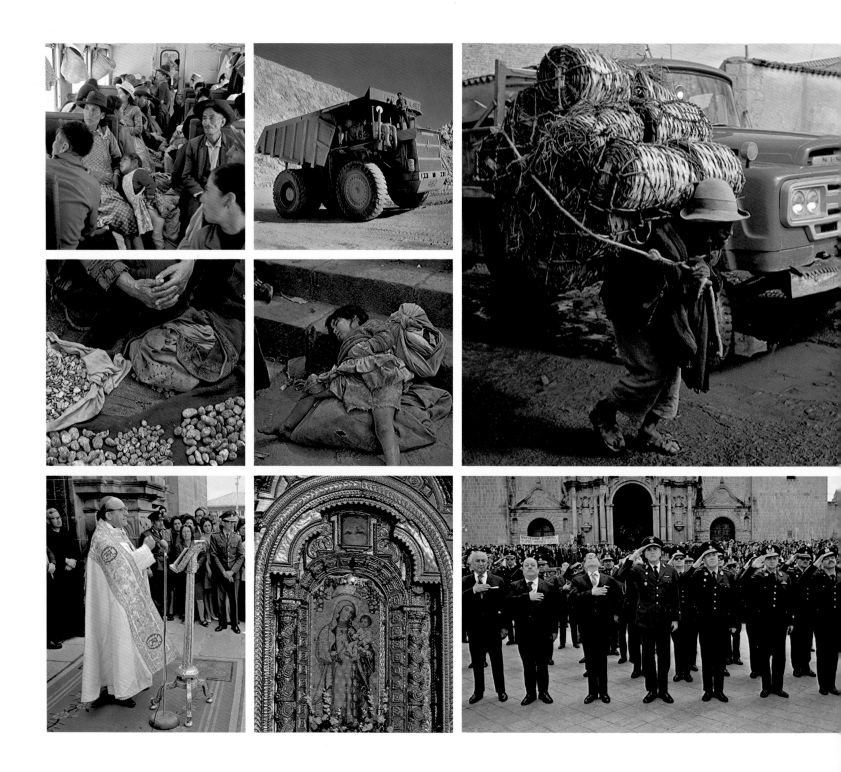

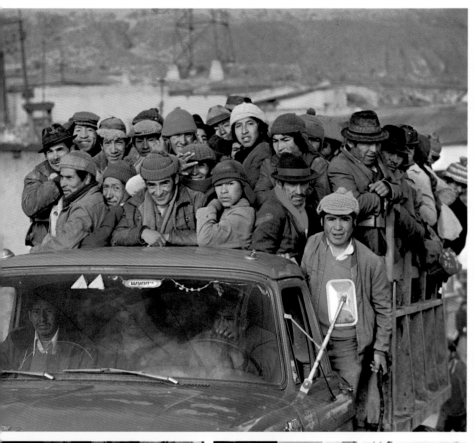
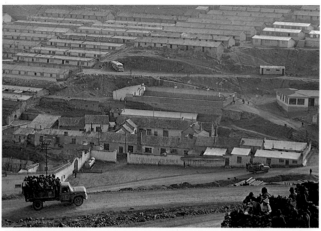
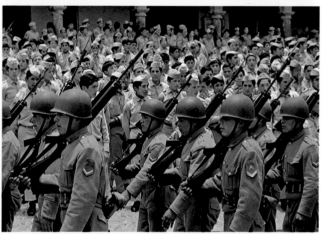

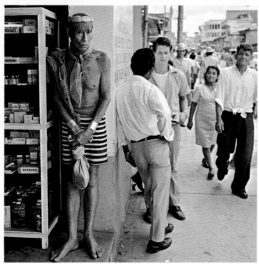
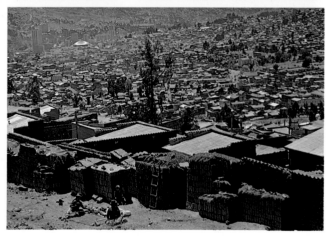

73

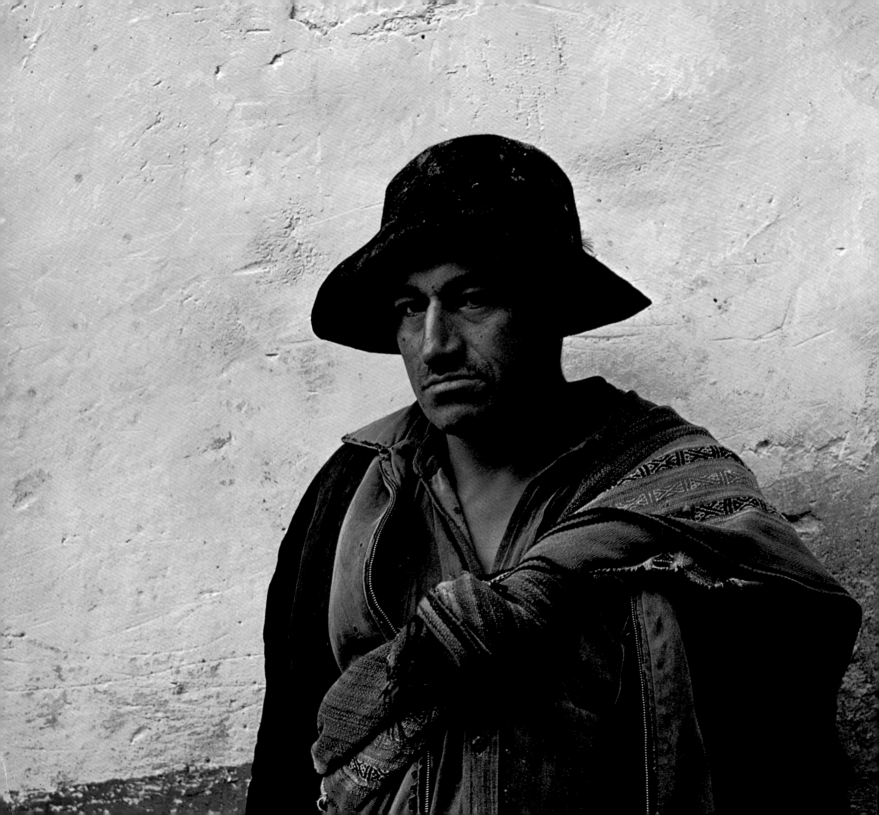